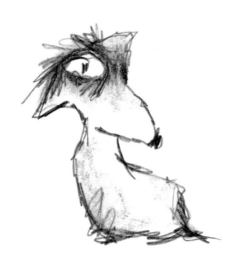

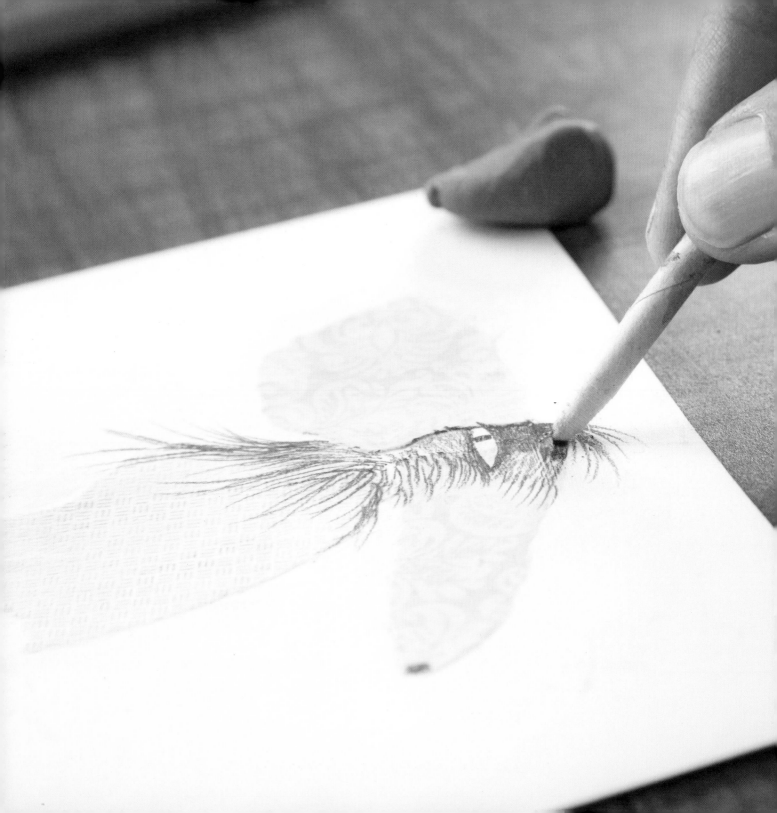

DRAWING AND PAINTING
IMAGINARY ANIMALS

A MIXED-MEDIA WORKSHOP WITH
CARLA SONHEIM

Author of *Drawing Lab for Mixed-Media Artists*

Photography by Steve Sonheim

Quarry Books
100 Cummings Center, Suite 406L
Beverly, MA 01915

quarrybooks.com • craftside.typepad.com

© 2012 by Quarry Books
Text © 2012 Carla Sonheim

First published in the United States of America in 2012 by
Quarry Books, a member of
Quayside Publishing Group
100 Cummings Center
Suite 406-L
Beverly, Massachusetts 01915-6101
Telephone: (978) 282-9590
Fax: (978) 283-2742
www.quarrybooks.com
Visit www.Craftside.Typepad.com for a
behind-the-scenes peek at our crafty world!

10 9 8 7 6 5 4 3 2 1

ISBN: 978-1-59253-805-8

Digital edition published in 2012
EISBN: 978-1-61058-628-3

Library of Congress Cataloging-in-Publication Data
Sonheim, Carla.
 Drawing and painting imaginary animals : a mixed-media
workshop / with Carla Sonheim.
 pages cm
 ISBN 978-1-59253-805-8
 1. Animals in art. 2. Mixed media (Art)--Technique. I. Title.
 N7660.S755 2012
 743.6—dc23
 2012006195

Design: Debbie Berne
Cover Images: Carla Sonheim

Printed in China

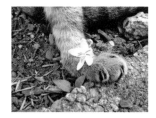

This book is dedicated to all of our
pets (including, but not limited to,
and in rough reverse order):

Natalie
Faelina
Jake
Roxy
Little
Joey
Jimmy III
Jimmy II
Jimmy
Charlie
Joan
Sammy
The Hermit Crab
Honeybear
two male tabby cats
Sarah
Porky
Rudy
an assortment of turtles, parakeets,
fish (including baby guppies),
hamsters, frogs, kittens
Rebel
Dawn
Nanette

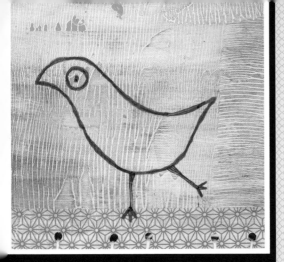

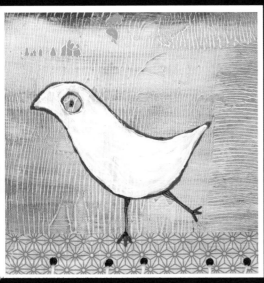

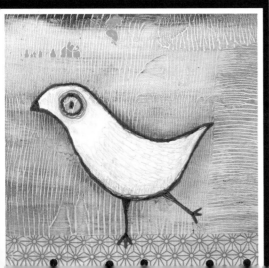

contents

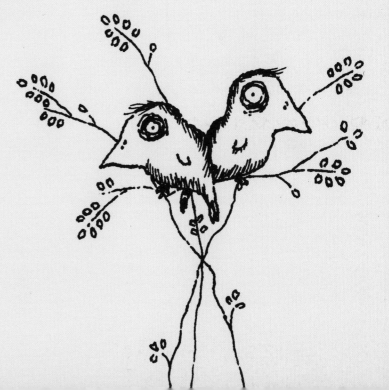

Author's Note

There's more than one way to ~~skin~~ DRAW a cat!

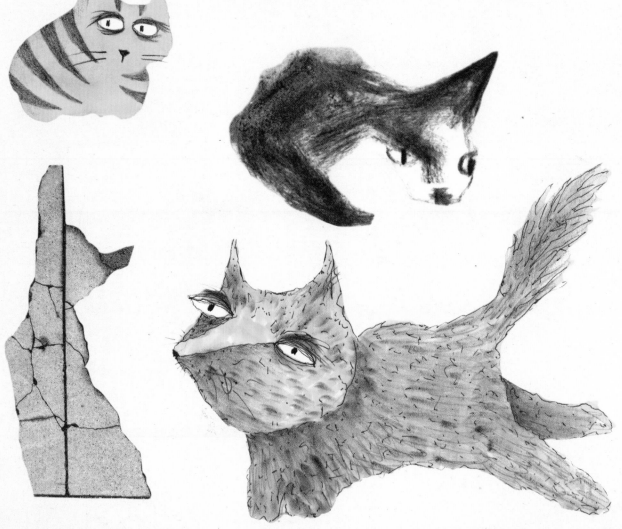

Let's get started!

Introduction

August 22, 2011

Today is the day I planned to start writing this
book, and I had wanted to get a strong start
first thing this morning. But it's eight hours later, and this is just the second
sentence out. And it's because of my pet, Natalie.

Instead of taking my son to an appointment and writing in the waiting room
with the laptop as planned, I took Wes to the dentist and a very sick cat to the
vet and forgot my laptop at home in the rush to get out the door.

One morning appointment morphed into an all-day affair, and by the time
I got home (4:30 p.m.) I was too tired/spent/mad to go into the office. I was also
many dollars poorer.

As we were driving home, Wes, sixteen, was disturbed by the amount of
money I had just spent.

He then asked, *"What do pets DO?"*

Ha.

Well, what DO they do???

I don't know. But I do know that plunking down a small fortune for some
X-rays, some fluids, and some assurance she didn't have kitty cancer was, if not
worth it, an acceptable price for what she does for our family:

She greets us at the door when we come home after school/work.

She gets her tail all up in a fuzz when she's happy.

She occasionally curls up on our laps.

She sleeps with or near us, snoring softly.

She meows loudly, and often, out of hunger, boredom, or desire to drive us crazy.

She makes an excellent zombie kitty.

Not to mention, she's so soft!

Anyway, the point is, I love animals. And lately that's all I've been painting and drawing, mostly from my imagination, but based on a lot of looking at animals: Natalie, of course, but also dogs at the park, iguanas at the pet store, and orangutans at the zoo. If there's an animal around, I'm looking at it. They are so interesting to me, each and every one!

Pablo Picasso once said, "I put in my paintings everything I like." In short, I draw and paint animals because I like them.

And I suspect you probably do, too.

about this book

I love very much to draw animals. —Josef Albers

I didn't really pick up a pencil until I was thirty and well into "life." I didn't go to art school even though I had artistic leanings; the adults and climate of the time just didn't provide enough encouragement for a person like me to buck convention.

(Ironically, I ended up with a B.A. in history, and there's nothing very practical you can do with that!)

Anyway, ten years later I started taking life drawing classes at a community college and also remember taking a watercolor class over a period of five Wednesdays at a local art league.

We had instructions when we signed up to bring several photo references of things we would like to paint. I brought some magazine images of elephants.

But when the class started, everyone else pulled out photographs of flowers. Flowers were everywhere, and I felt embarrassed and stupid: what was I doing in a watercolor class, anyway? I couldn't even pick the right subject matter!

While the other students made their first marks, I made plans with the door. But the instructor noticed my hesitation and asked what was wrong. I confessed that I just didn't want to paint flowers.

She asked me to show her the images I had brought. When I pulled out my elephants, she laughed and said, *Paint what you want to paint!*

Phew!

My first book, *Drawing Lab for Mixed-Media Artists: 52 Creative Exercises to Make Drawing Fun*, shared both realistic and stylized ways of drawing many different subjects. I intended it to be a survey book and hoped that with the many drawing styles presented, it would hold something interesting for many people.

This book is more specific to my preferred way of working: more stylized, from imagination, and with animals as my chosen subject matter.

WHY ANIMALS?

Besides being just fun to have around, pets teach us how to be.

Cats give us confidence to ask for what we want, and dogs help us remember the other guy. Hamsters

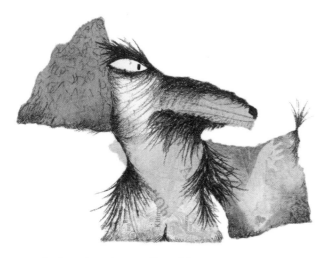

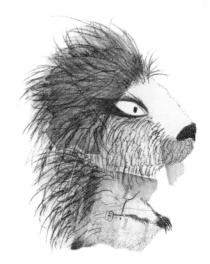

remind us that the small and furry are pretty cute. Horses are gentle creatures, but if they step on your foot, watch out: they're heavy! And rats remind us that creepy tails do not mean a thing.

Wild animals teach us, too. Birds give us the hope that we can fly, if only metaphorically, and elephants remind us that it's okay to be gray and wrinkly. Ants remind us that a lot can be done with teamwork, and that there's no excuse not to carry your own weight.

Anteaters are good at reminding us that wonky nose parts (or other parts) just make us uniquely us, and vultures remind us that ugly can actually be kind of cool. Zebras remind us that fashion is fun sometimes, and giraffes remind us to not take ourselves so seriously.

And fish remind us that truth is stranger than fiction. (Have you been to an aquarium lately? You should go.)

Drawing and painting can teach us, too. The things I've learned from drawing have applied directly to approaching all other areas of my life, including relationships, exercise, work, and handling difficult circumstances.

Basically, with both art and life, I take a stab in the dark. I make a play. Then I assess it, deal with it, and try again, correcting and adjusting if I need to. I always aim to do better the next time. In both art and life, I sometimes have bad days. But then I have great days, and all is well again. Sometimes I'll take a rest—a nap in the middle of the day kind of thing—and I don't draw or paint for a while. But then I wake up refreshed and ready for the next challenge: the blank canvas or piece of paper.

And like the animals, the art we make teaches us to accept who we are. For example, a weird errant line just makes a piece uniquely mine (Anteater Lesson), and my somewhat dull color palette is really okay (Elephant Lesson).

A NOTE ON MATERIALS

I have a studio full of art supplies I rarely use. In the end, I prefer to work with a fairly small list. With a few exceptions, the following is all you will need to do the projects in this book:

- mechanical pencil
- Ultra Fine-Point Sharpie (permanent marker)
- ballpoint pen
- white paint pen
- watercolors
- #12 round watercolor brush
- soft vine charcoal
- white gesso

- white acrylic ink
- colored pencils
- markers (any kind)
- 1 or 2 light-gray Copic markers (or something similar)

I work in small 5½ x 5½ inch (14 x 14 cm) sketchbooks, on white card stock from the office supply store, #140 hot-press water-color paper, or wood.

All artwork is by the author unless otherwise noted.

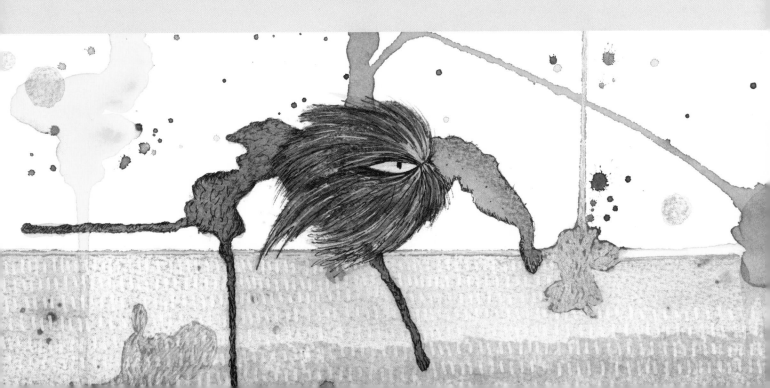

1 Just MESSING AROUND

SKETCHBOOK PLAY AND OTHER NONSENSE

"Time you enjoy wasting is not wasted time. "
—Marthe Troly-Curtin

This first section consists of drawing exercises and painting prompts that I typically do just for fun. Sometimes these exercises influence my "real" work, but often they don't seem to make much practical sense at all.

I do them because I know that "time-wasters" (such as one-liners or blind drawings) help inform the new animals I create. Sometimes the things that seem to make the least sense at the outset provide inspiration for the very thing you particularly like the most.

The more you can open yourself up to new and silly ways of drawing and painting, the more primed you are to approach your "real" artwork with a spirit of relaxation that, ironically, often leads to the most satisfying results.

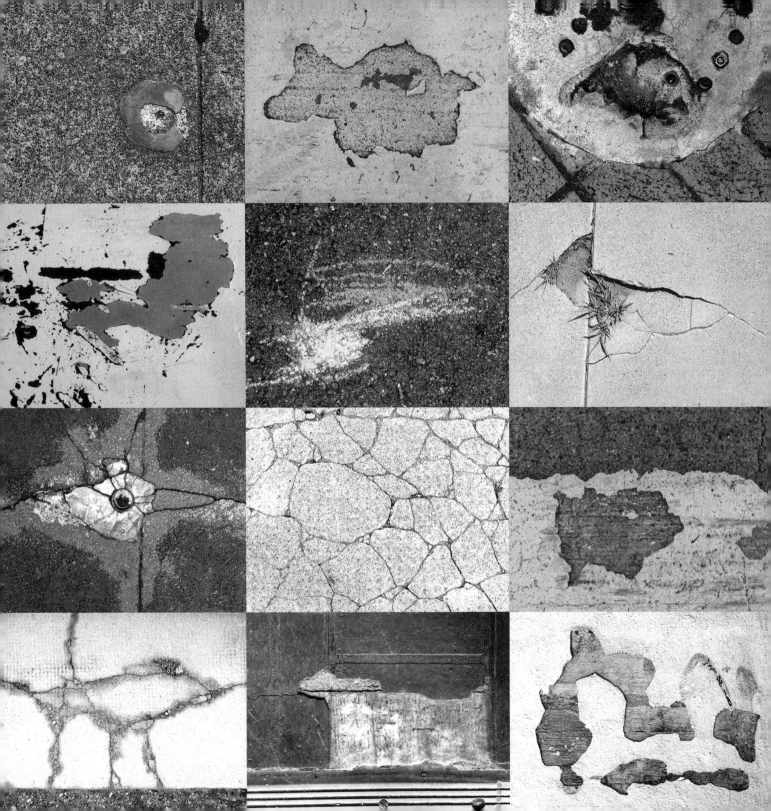

1

Blobs and Sidewalk Cracks

Finding Animals Around You

I SEE ANIMALS EVERYWHERE!

Because I live in the City of Seattle, I am fortunate to have access to lots of city blocks that have oil stains, trash, and other random "blobs" to draw from. When I lived in Colorado, I was fortunate to live in a very small town with plenty of run-down walkways that provided tons of inspiration: sidewalk cracks.

Wherever I've lived, during the fall months I'm fortunate to see leaves on the ground that become fish, birds, elephants, and other creatures as I pass by. And in the produce section yesterday I was fortunate to run across a huge pile of ginger roots, er . . . fluffalumps, cats, elehorses, and toads.

The point is, I see animals everywhere and so can you. It's just a matter of training your eyes!

It turns out that tinfoil and ginger roots make excellent animal references.

One student recently asked if I always start my animal drawings from "something"—a blob of paint, an abstract watercolor start, a sidewalk crack?

Most of the time I do, yes. When drawing from my imagination only, I seem to fall back on clichès and am rarely happy with the outcome. But when a creature is pulled out of a found shape—already half started in my mind's eye (which, apparently, is more creative than my regular hand/eye)—it turns out to be much more unique and lively.

For example, if asked to draw an elephant from my "head," my first impulse is to draw something like this:

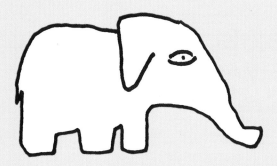

It's okay. Cute, I guess. But if I "find" an elephant in a found shape, such as a sidewalk crack, a leaf, or a smashed-down piece of paper . . .

. . . then I can turn it into an elephant that looks like this:

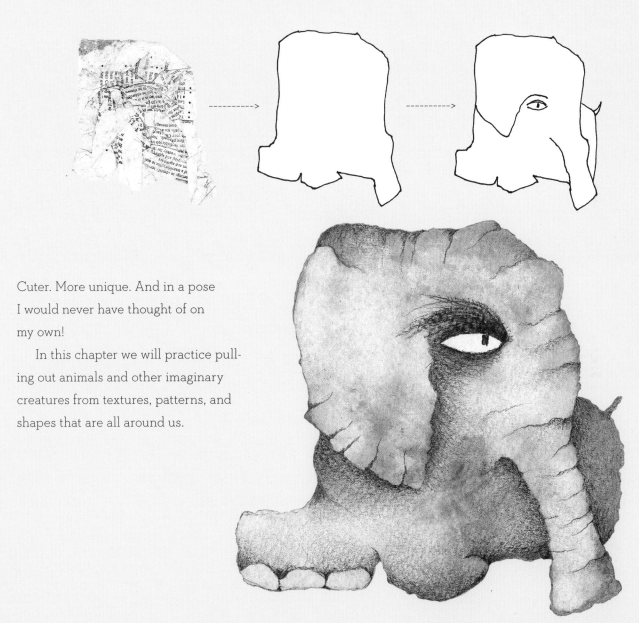

Cuter. More unique. And in a pose I would never have thought of on my own!

In this chapter we will practice pulling out animals and other imaginary creatures from textures, patterns, and shapes that are all around us.

Line Blobs

I started creating "blobs" in order to solve a problem I was having: the blank page scared me! So a few years ago I decided to prefill my sketchbook pages with shapes found in sidewalk cracks, tree bark, leaves, and the like. I could do this when going about my day, with no pressure to draw on the spot—just a quick shape. Then, when I felt like sitting down to draw, I had something already on the page to bounce off from. A problem was there for me to solve.

materials
- *paper or sketchbook*
- *fine-point permanent marker*
- *walking shoes*

To begin, go outside and take a walk around your garden or neighborhood.

❶ Record shapes you see that interest you. It's not necessary (or even desirable) that you see an animal in these shapes now; just record about six to ten shapes that you find interesting or that you think might have the potential of becoming an animal.

❷ Some ideas of where to find shapes include bricks, dirt and soil, stones, water marks, leaves, sidewalk cracks, oil stains, a child's chalk drawing, bark on trees, dying flowers, snow, bird excrement, peeling paint, rust stains, trash, and food.

❸ Go back to your studio or a quiet place and pick one shape to work with.

❹ Look at and see if you can see an animal; if so, great! But before you continue, turn your paper (or sketchbook) around and around all the way. Perhaps there is an even more appealing creature waiting for you.

❺ Add eyes, feet, a tail or any other characteristic needed to finish your blob animal.

❻ Add cross-hatch marks (shading) under the eyes, chin, ears, or legs if desired.

❼ Remember to try and keep a non-precious mindset as much as possible. It's just pen and paper!

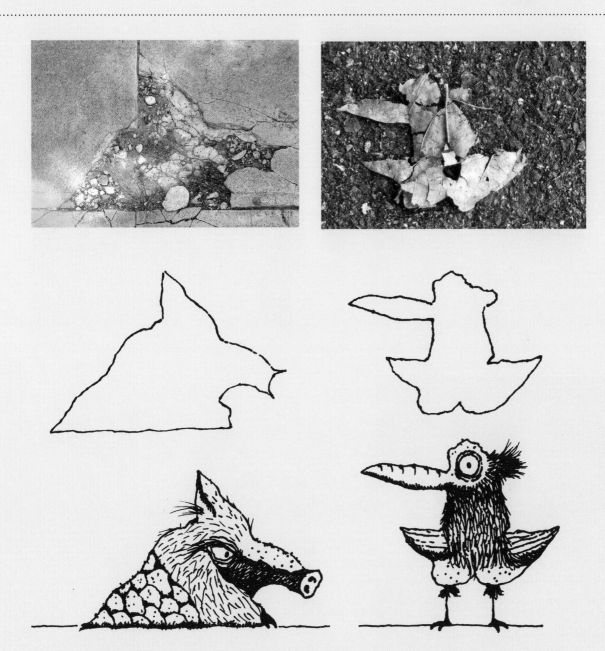

These two unlikely creatures were inspired directly by the two photos.

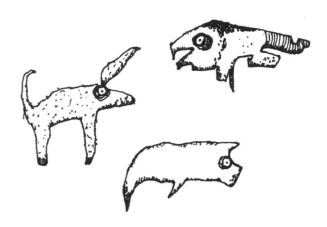

▲ You can even draw from 10,000 feet (3 km)! These line drawings were inspired by shapes seen outside of an airplane window somewhere over Kansas.

Blob hunting in the Pioneer Square neighborhood of Seattle

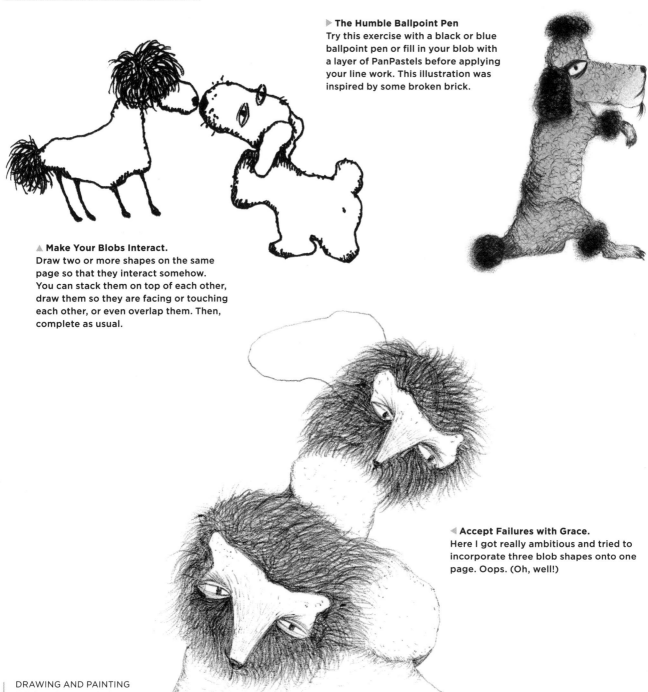

The Humble Ballpoint Pen
Try this exercise with a black or blue ballpoint pen or fill in your blob with a layer of PanPastels before applying your line work. This illustration was inspired by some broken brick.

Make Your Blobs Interact.
Draw two or more shapes on the same page so that they interact somehow. You can stack them on top of each other, draw them so they are facing or touching each other, or even overlap them. Then, complete as usual.

Accept Failures with Grace.
Here I got really ambitious and tried to incorporate three blob shapes onto one page. Oops. (Oh, well!)

◀ Let the Media Determine Outcome.
Charcoal, for example, just seems to
demand a sketchier, looser line. This
example was done with a medium
charcoal pencil inspired by a ginger root.

▽ Just Add Water.
Draw your blob with a water-soluble
marker or pencil (such as an Inktense
pencil) and add water to spread the
pigment for shading and coloring.
This illustration was also inspired by
a ginger root.

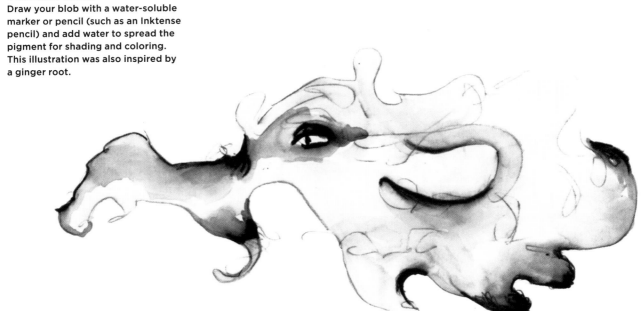

Coloring Your Blobimals

Next we'll add color to our blob animals with transparent layering!

In my drawings and paintings, I like to build color very slowly, using multiple layers of transparent color. For this reason, I rarely grab a dark brown or blue marker for the beginning steps; darker colors are usually saved for the last detailing step (whiskers, etc.).

In this exercise, you will use colored pencils and lighter-hued markers to add texture and life to some of your line blob creatures.

materials

- *watercolor paper or sketchbook*
- *water-soluble markers*
- *several alcohol-based markers, such as Copics, in light colors: gray, blue, pink, or yellow*
- *colored pencils*
- *pencil*

1 Choose a light-colored marker and color in several areas of your animal.

2 Grab a second marker and add a textured layer over the top of the marker.

3 Now add a layer of colored pencil. (I usually have a very light touch in the earlier stages.)

4 Now either stop (if satisfied) or keep adding layers of marker or colored pencil.

5 Play around with different marks such as dots, lines, or "hair."

6 Repeat the exercise with a different combination of markers and colored pencils, always stopping when you are satisfied with the color and pattern.

7 If desired, keep a little key next to your animal showing the media you used; it might be something you will want to refer to in the future.

▶ **Stacked Bird Chart.** Making a chart like this is a great (and fun!) way to figure out effective color combinations for future animals.

▼ I use all kinds of markers and colored pencils; both inexpensive water-soluble markers from the grocery store and more expensive Copics are used together. (Since I am basically unorganized and a tiny bit lazy, I use whatever is handy at the moment.)

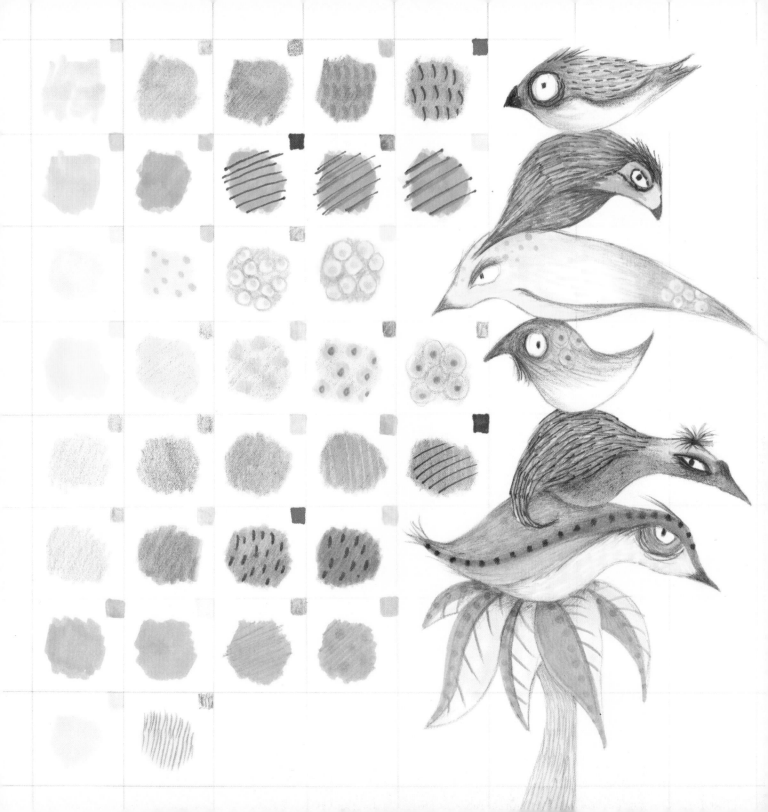

Here is a step-by-step process of how I might layer markers, colored pencils, and pencil on works on paper.

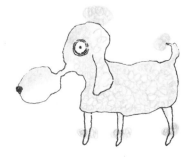

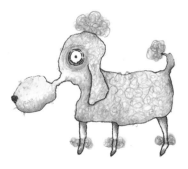

❶ I drew a quick line-blob drawing based on peeling paint on a wall in Puerta Vallarta, Mexico, while on vacation in 2010. I used an Ultra Fine-Point black Sharpie (permanent marker).*

❷ This shape reminded me of a poodle, and poodles have curly fur! So I started making the curly marks with a light gray Copic marker (#N1). I like Copics because they come in a whole range of very light colors, which support the layering process. I "puffed out" some poodle hair on the head, tail, and feet.

❸ I added gold colored pencil (just a Crayola I had lying around). Instead of pressing really hard at this point, I applied light pressure; since I'm going to be adding more layers of color on top later, I know that even though the color might look "blah" right now, it will *build* into something more interesting as I go along.

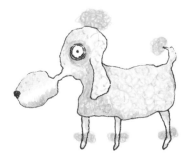

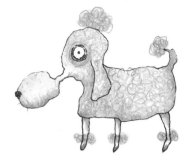

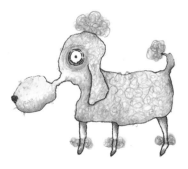

❹ I added a layer of pink Crayola marker. Since it was a comparatively darker shade, I added it to the areas of the dog I thought might be in shadow, such as the bottom of its snout, around its ears, and so on. I also threw a few random pink marks in the body to tie it together.

❺ I added red colored pencil in similar areas. I worked both the lighter touch and a few darker lines for the curls and toenails.

❻ I added some pencil shading using a regular mechanical pencil. I tried to get the darker pencil into the nooks and crannies where I imagine shadows might be (under the hair tuft, for example). I softened the graphite lines with my finger.

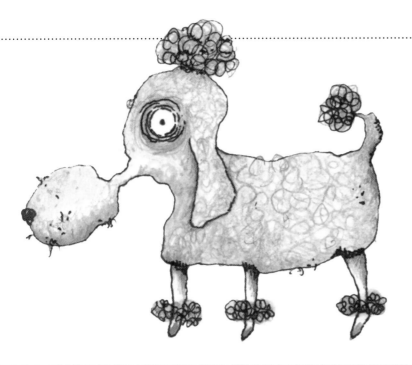

7 The strong line of the original sketch around the fur tufts on the legs bothered me, so I finished by going back in with the black Sharpie and adding more dark lines to the tufts of hair to try and obscure those original lines a bit.

✳ Having recently discovered that I really liked the delicate line work one can get with a ballpoint pen, I brought a new sketchbook to Mexico with a plan to fill it with blob shapes using just a ballpoint. I started to fill my sketchbook one day with peeling-paint-inspired blobs while walking around a small village. But I only made it about ten pages in before the pen ran out. Shoot! I tried everything to get it to work again, and even did about ten "drawings" that were nothing more than indented marks; no, it was dead.

Since there were no ballpoint pens for sale in the little kiosks we were passing by, I had to use the only other pen I had on me: a black Sharpie. I was so looking forward to completing a cohesive series of animals! Instead I have three different kinds of lines to work with, one of which you can't even see!

Drawing/Life Lesson: Things don't always go the way you want them to, but in the end, it will probably be okay.

Here are three finished drawings from that "series."

Exploring a Single Sidewalk Crack

If you were to look at the photos on my digital camera, you might wonder a bit about my priorities. About 90 percent of the images are "blobs and sidewalk cracks." Another 8 percent are photos of textures such as brick walls, stucco, wood grain, and the like. The final 2 percent consists of my beloved family members. Sigh. My only defense is that these images come in handy for actual art making, which is part of my *job*, you understand.

In this exercise, you will push yourself to explore the numerous creatures you can squeeze out of a single sidewalk crack photograph.

materials
- *printing paper*
- *ink-jet or laser printer*
- *white gesso*
- *small flat brush, about 1/4" (6.4 mm)*
- *watercolors*
- *materials of your choice*
- *camera*

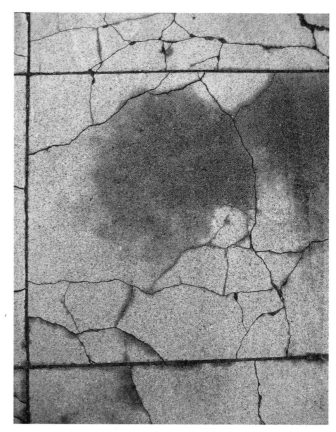

This sidewalk pattern inspired the artwork on the next three pages.

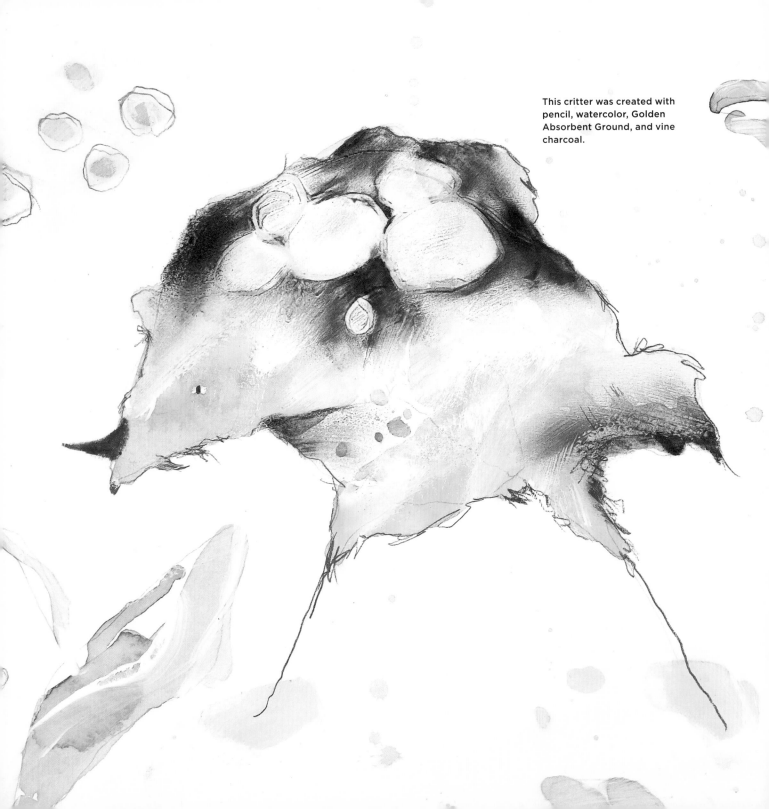

This critter was created with pencil, watercolor, Golden Absorbent Ground, and vine charcoal.

Option ❶ Take a photo of an intricate sidewalk crack (or use the one on page 38). Print it out on six to ten pieces of heavier paper. Now take gesso and a small flat brush (for getting into the nooks and crannies of the cracks) and obscure everything but a creature. Set aside and repeat. See how many creatures you can find from a single sidewalk crack. Don't forget to turn your paper all directions!

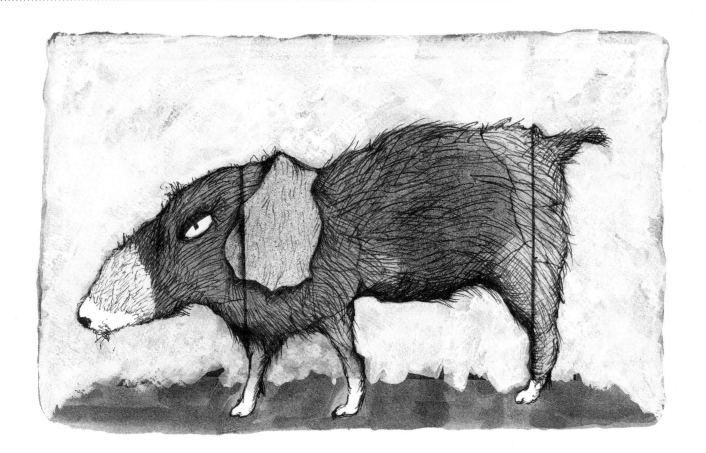

▲ **Option ❷** Three-legged dogs are surprisingly common where I live. Print out your same sidewalk crack on nicer paper (I used Canson brand Arches Aquarelle Rag) and see if you can create a creature by extending your drawing out from the photograph. This one was finished with watercolor, ballpoint pen, and white gouache.

▶ **Option ❸** Use the sidewalk crack shapes for inspirations for freehand drawings. This bird was drawn lightly in pencil directly on the watercolor paper, using the sidewalk crack as inspiration for the shapes, then finished with watercolor and pencil (and eraser).

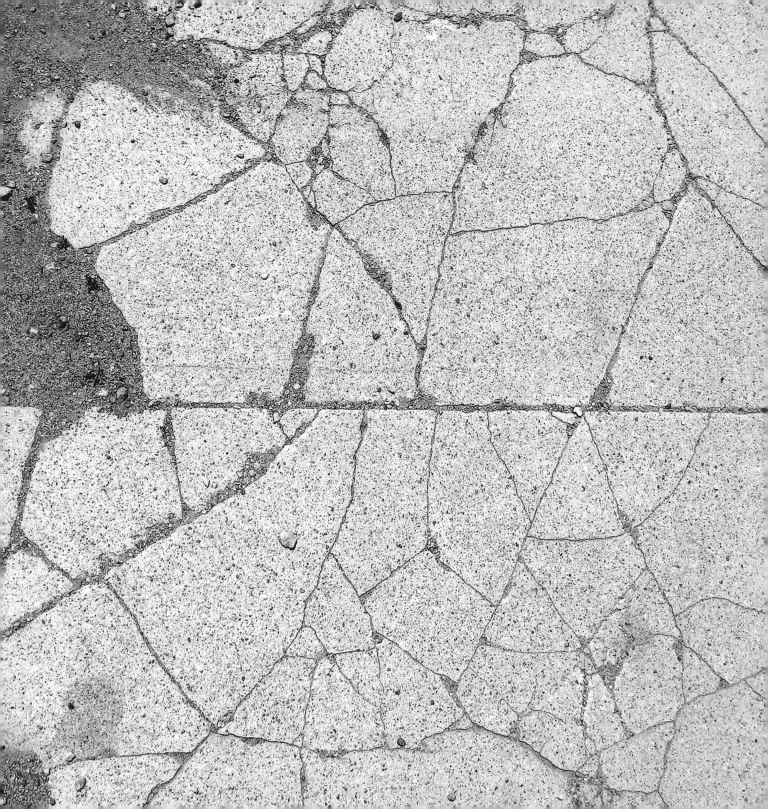

I sent this sidewalk crack image to two artists and asked them to use it as inspiration for an art piece. Here are their takes. What about you?

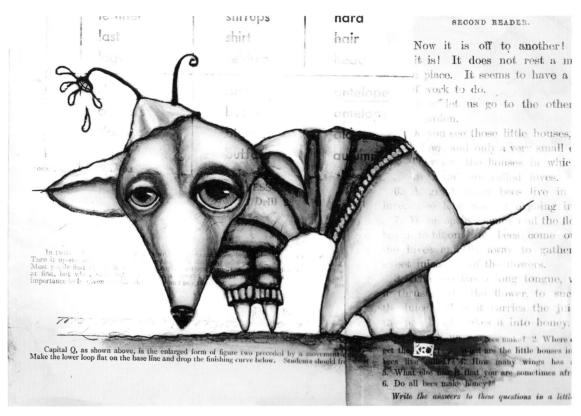

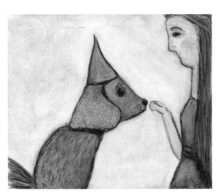

▲ *Wannabee* by Karen O'Brien
pencil, watercolor pencils, white gouache, and pen on collaged paper surface

◄ *Dog and Girl* by Lisa Firke
watercolor, gesso, and colored pencil on watercolor paper

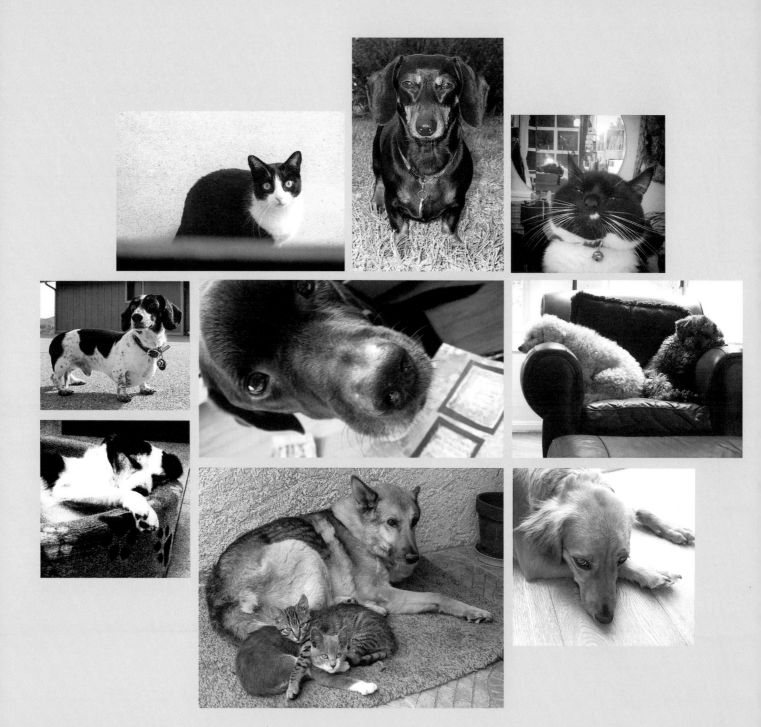

2

Photos and Life

Drawing Animals
around You

All things work together, and the more you draw from life and photo references, the more "real" your imaginary creatures will be.

Arthur Zaidenberg, an instructor at New York University in the 1950s, writes: *Reproduction is not the function of the creative artist. It is especially not in the province of drawing. The nature of drawing permits the quick capture of fleeting impressions.*

I am rarely interested in drawing animals in a precise, "realistic" manner. And yet, I know that drawing from life as much as possible—as well as spending time really looking at animals, either from life or photographic references—will result in more authentic stylized creatures.

Since drawing realistically is not first on my drawing to-do list, I have needed to find ways to make photo and life sessions "fun" for me; otherwise, I simply wouldn't do them.

Zaidenberg continues: *The whole personality of the artist must enter into the [drawing] process. To the student it cannot be too forcibly stressed that apathy of the eye and mind, no matter how great the skill of the hand, makes for a bad drawing.*

In this chapter, we will draw from life and photo references, albeit in somewhat roundabout ways.

Pet photography provided by contributing gallery artists

Drawing Blast

I do the exercise as often as I can, usually about twice a week. The following five drawing exercises are completed in one twenty-five-minute session with the same photo reference.

If drawing realistically scares you, try doing these exercises on cheap paper and with the intent that you are never going to show them to anyone. Your main goal with these drawings is only to fill your subconscious with the details and peculiarities of the animal you have chosen.

I start by going to my stash of animal magazines and books (or online) and just pick the first animal that looks fun to draw. I set my timer for five minutes and start the first drawing prompt; when the timer goes off, I start it again and go to prompt #2 on a new page. I try to get my head in a space where outcome isn't important (always the trick).

Setting the timer and just doing it is way easier than fretting about it. Just pick something and go. You'll be surprised how fast this twenty-five minutes will pass!

materials
- 5 sheets of card stock
- fine-point permanent marker
- photo reference of an animal
- timer

❶ Wrong-Handed Drawings

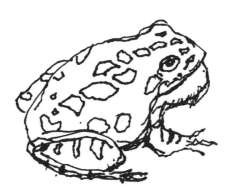

❶ Wrong-Handed Drawings. I am right-handed. So for the first five minutes, I put the pen in my left hand and draw my reference as well as I can. Yes, the lines are shaky and sometimes very interesting slips occur, causing the drawing to be fairly crude. I don't care. I'm concentrating on looking at my reference more often than my drawing and trying to make my weak hand work as well as I can.

I went running the other day on a narrow path, something I'm not used to. I had to concentrate really hard on each step so I wouldn't fall. This is what drawing with your wrong hand does; it puts you in a slightly uncomfortable place and forces you to focus all of your attention on just getting the pen to move in the right direction. This frees up the other part of your brain to *absorb* the subject matter more fully.

❷ Blind Contours. The next five-minute block is spent doing several blind contour drawings, an exercise designed only to get your hand and eye moving together; the outcome is definitely not important here.

Look at your reference the entire time and never at your paper. (Some people find it helpful to actually hold their reference photo up above their paper, blocking the view of the drawing, so as to not accidentally cheat.)

Fix your eyes on the edge of your reference and set pen to paper. Now, *very slowly* start moving your eyes and your pen at the same speed down the edge of your subject. If you start to feel panicky, that is a clue for you to slow down even more. Since these are done without looking at your paper, you are not worried if the outcome is funny, right? In fact, if they don't look funny when you're done, you've probably peeked by accident.

❷ Blind Contours

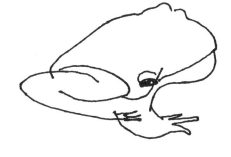

3 Contour Drawings. These are done exactly the same way as blind contours, only now you can look at your paper as you draw. (Still, though, you should be looking at your reference *more often* than your drawing.) Continue to work very slowly and just concentrate on moving your eyes and hands along the edges of your subject at the same speed. Record every bump and curve. Don't forget to breathe!

This exercise is often the "hardest" because it's easy for your inner critic to kick in. If this should happen, just focus and do your best to be gentle with yourself. Remember that these drawings are for practice only and that the main thing you are doing right now is practicing looking intently while also moving your pen. The outcome is still unimportant.

4 Scribbly Drawings. This is one of my favorite exercises to do, but it's sometimes a trick to change gears so quickly from the contour drawings. That's okay.

Start scribbling vigorously from the *inside* of your subject and work outward (switching gears totally from the previous prompts).

Scribble harder and more densely in the darker areas and looser and lighter in the lighter areas. (Squinting your eyes might make it easier to distinguish the lights and the darks.) Don't think too much, just scribble quickly. These drawings should take about a minute each (or less). When you feel done, stop and move on to another scribbly drawing on the same page. You might end up with one big scribbly mess at the end, but that's okay, too!

Remember, you don't want to just scribble the contour edges, but endeavor to draw the *mass* of the creature.

5 Cheater Blinds. Now we'll slow down again with a combination of a contour and blind contour drawings. I have found that I really love the "look" of blind contours; they end up being kind of wonky and weird, and I like them. (But since you are not allowed to look, the results can be a bit un-animal-like.) We want to retain the "off" look of blind contours and have a recognizable animal in the end.

With cheater blinds, you are allowed to look at your drawing two or three times during the course of your first outline. (I like to do the outline step with a thicker marker.) Then, once your shape is blocked in, you can switch to a thinner pen and look at your paper as much as needed to add details such as eyes, wrinkles, and shading. But be sure to still refer to your reference for shading help!

3 Contour Drawing

4 Scribbly Drawings

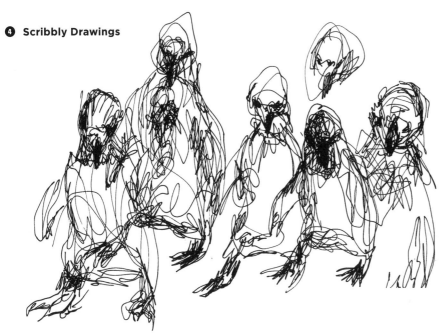

5 Cheater Blinds

Eraser Drawings

In the previous exercise, we worked in permanent marker and erasing wasn't an option. This is a great way to draw; having no means of correction forces you to spend your efforts looking rather than erasing. Ironically, many people find drawing in permanent marker to be very freeing!

In this exercise, we'll do exactly the opposite: you will "draw" with the eraser. This is also freeing because we can be confident in any line we make, knowing that we can just erase it if needed. We relax and hopefully make better drawings because of it.

We're also practicing shading, which will give you the information you need to determine how to shade any imaginary creatures you create.

materials
- *sketchbook, card stock, vellum, or tissue paper*
- *mechanical pencil with eraser*
- *photo reference of an animal*

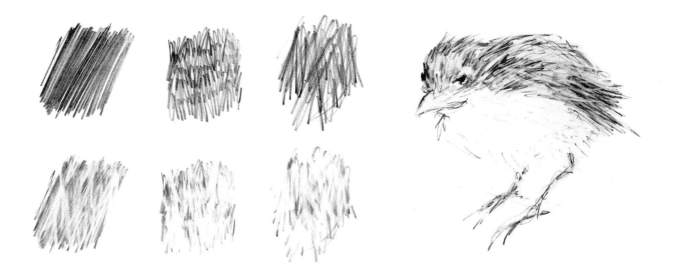

▲ The patches on the top row were created with mechanical pencil; directly beneath are the same patches after drawing into them with an eraser.

❶ To begin, find a photo reference of an animal that looks fun to draw and lightly sketch in its shape. Work pretty small, about 3 to 6 inches (7.5 to 15 cm). This first step should only take a few seconds.

❷ Draw in an eye or two and then start scribbling a mass of dark graphite lines.

❸ Once you have a mass in an area, look at your reference and start "drawing out" the light parts with your eraser. Vary your eraser pressure so that you have a range of lights and darks. Don't forget to refer to your reference often!

❹ If you erase too much in an area, just add pencil back in and begin again.

❺ Once you are satisfied with your drawing, immediately begin another animal right next to it, creating a new breed if desired.

tip ▶ Sometimes with these drawings you may need to cut your losses and move on to the next one before you are "satisfied." It might not be the most realistic rendering of an elk ever made, but you did your best, pushed it just a little further than felt comfortable, and now can be content to call it a day and move on.

▲ It's fun to realistically render animals that don't really exist. This is mechanical pencil on vellum.

Bits and Pieces

I feel shy and self-conscious when drawing in public. The thought of someone looking over my shoulder and judging my efforts make me a little tense. So during a recent zoo visit I tried something else: I decided to only focus on *parts* of animals, rather than their wholes. My idea: if I drew a foot or an eye and someone looked over my shoulder, it would be harder for them to judge my proportions harshly. (I know, I'm crazy. But it's all in an effort to trick myself into just concentrating on looking and drawing and not worrying so much about my results.)

You might draw an eye of a Komodo dragon on one page and its claw on another; the head of the baby kangaroo on the third; and a gesture drawing of its body on a fourth page. This exercise gives you a lot of wonderful starting points to work with when you are back in the studio later.

materials
- *sketchbook*
- *ballpoint pen*
- *charcoal pencil*
- *live animals if possible (like a zoo visit); otherwise, photo references are great*
- *optional: watercolors, colored pencils, etc.*

❶ Gather your sketchbook and materials and find an animal that is close enough to draw.

❷ Sketch a paw, an eye, or a head shape. Keep your hand loose and scribbly.

❸ Turn your sketchbook page and repeat step 1 with another body part.

❹ Do several small gesture drawings of the animal on a third page. (Gesture drawings are very quick sketches where you try to capture the essence, or movement, of a subject.)

❺ In addition to drawing animals, draw shapes and textures of various plants, leaves, and flowers as you walk to other zoo exhibits. Use both sight and touch for your input (see sidebar on page 51).

❻ Repeat steps 1 through 4 until you have six to eight pages of your sketchbook filled with animal and plant fragments.

▶ Here are some animal and plant "fragments" created in one drawing session at the Woodland Park Zoo in Seattle. I had arrived somewhat unprepared and only had a charcoal pencil, so I borrowed a ballpoint pen from the check-in guy.

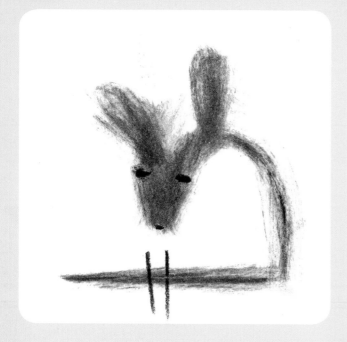

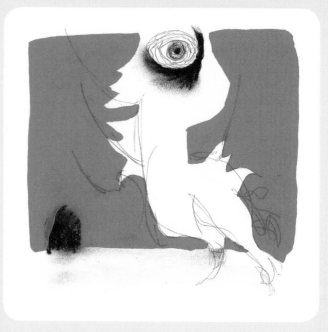

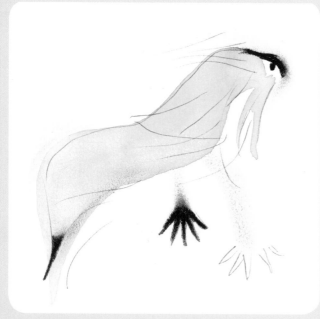

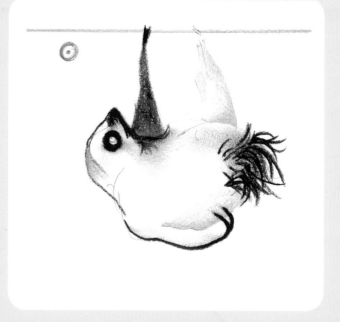

touchy feely

Recently I picked up a great book by British painter Emily Ball, *Drawing and Painting People: A Fresh Approach*. One of the most surprising exercises for me was one where we did a blind drawing of our own faces, using only touch as our stimulus.

The reason I was so surprised is, even though my finished drawing was typical of a blind drawing—definitely not "accurate"—the nose was one of the most "real" I've ever drawn.

This is a wonderful way to approach drawing and painting (that we can use all our senses, not just sight, as starting-off points).

▲ Dried seed pods, leaves, and other natural matter are fun to draw by touch only. In addition to placing your animals in an environment, plant textures can be repurposed and used as fur, hides, scale markings, and so on.

◀ The scratchy marks in ballpoint pen were "leaves" made with my eyes closed, using only touch as the stimulus.

◀ Later, back in your studio, use watercolor, gouache, or other media to "finish" your pages using memory and imagination. The stylized kangaroo (top, left) was created immediately after the zoo visit, while its unique characteristics (e.g., the dainty front paws) were fresh in my mind.

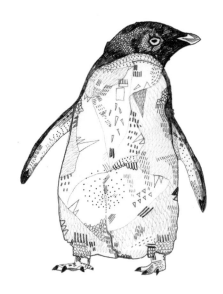

Ostrich *by* Petra Overbeek Bloem
Chinese ink on rice paper

"The consequence of this technique is that you cannot work on a piece for months, like an oil painting. These paintings are made in an instant (the ostrich in one breath). But on the other hand, I make the same painting a dozen, maybe a hundred, times. And throw it away ninety-nine times. During this process, the image gets more abstract every time, and I find it difficult, once I have reached an abstract level, to turn back to an earlier more figurative way of painting."

Penguin *by* Sandra Dieckmann
pencil on paper

This was part of an illustrated series of ten of the most endangered animals on the planet, created in collaboration between Sandra and Jamie Mills.

▶ **Raven** *by* Marina Rachner
pen and watercolor on paper

"I found the photograph of a raven in a magazine and portrayed the bird's head. I then continued with the human body wearing something like a tailcoat that also looks like bird's wings.

"The blending of animal and human being is what appeals to me most because it enables me to express feelings in a different manner. The effect this blending has on the viewer in my opinion is very interesting."

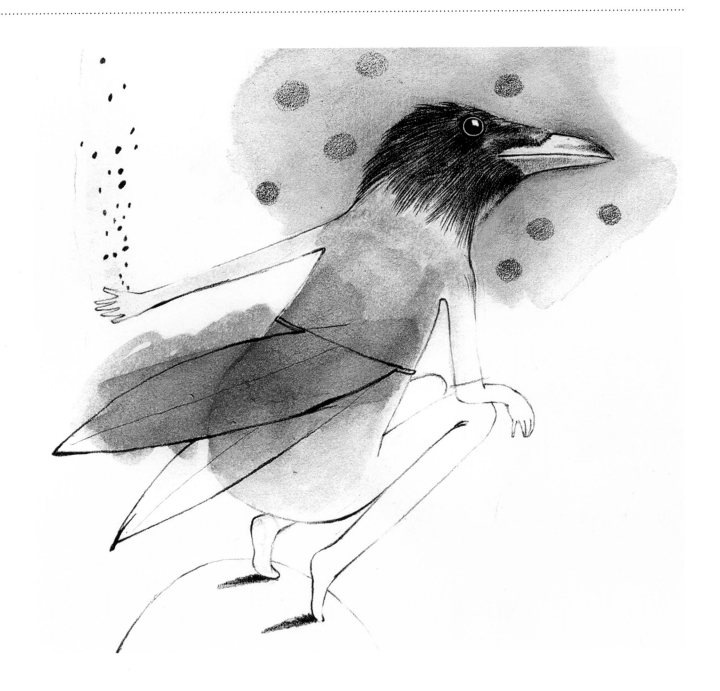

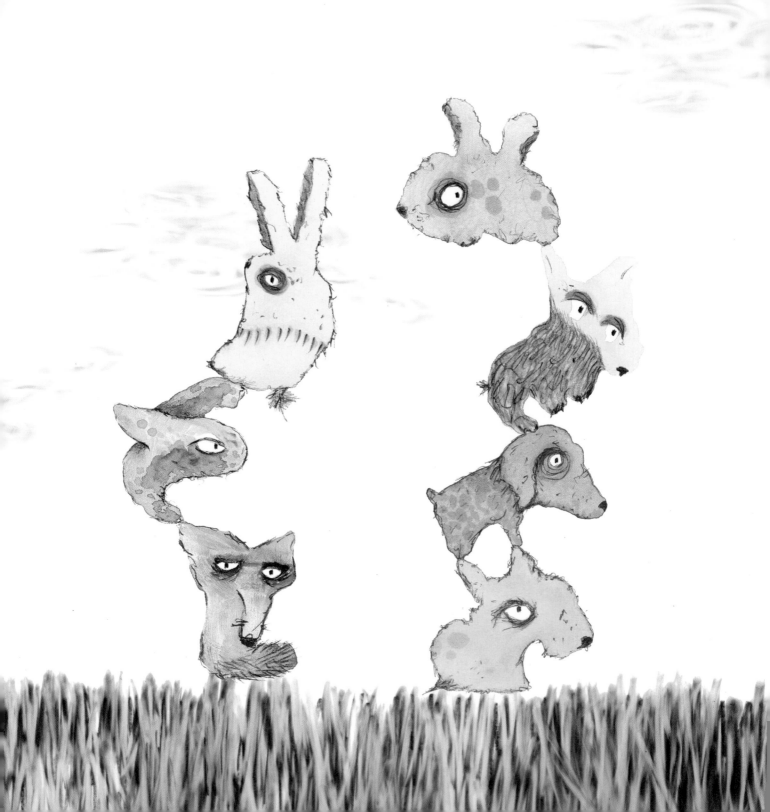

3

Memory and Imagination

Drawing Animals within You

SOMETIMES OUR SUBCONSCIOUS KNOWS BEST.

Some people would even say that our gut, intuition, and "blink" impulses *always* know best. For this reason, I approach a lot of my sketchbook drawings with exercises that allow my subconscious to be in the driver's seat. (Because, if asked, I would tell you that I don't feel like I have a very good imagination. It seems that anything I come up with appears by accident, and for some reason that seems like cheating to me. I get around this lack of creativity by giving myself "assignments" such as those in this chapter that help to get my subconscious in gear. Because nothing freezes me up quite so quickly as the blank page: if I don't help it along, my "imagination" fails me every time.)

Some of these exercises result in finished drawings and others are designed just to get the hidden stuff out there, hoping some cool creatures will emerge that I can later reinterpret in more developed drawings or paintings.

These watercolor blobimals (exercise #9) were created separately and combined digitally.

Scribbles Galore

In the following exercises, you will create your own "blobs" from your imagination only. These random lines, marks, or patches of color (that you will first lay down with little or no thought as to final outcome) will then give you something to finish.

materials
- *stack of card stock*
- *sketchbook*
- *Ultra Fine-Point Sharpie (permanent marker)*
- *black or blue ballpoint pen*

❶ Loopy, Scribbly Blobs. One of my favorite activities as a child was to do "scribble drawings" where I made a random squiggly line on a piece of paper and then tried to "find" an image in it. The following exercise is similar, but the lines are just a little loopier, more intricate and flowing, and more "bloblike."

- Take a breath and put pen to paper; then go! Start drawing some loose, loopy, scribbly lines.

- Work in a herky-jerky manner; for example, do a large loop very quickly, then stop and do some scribbly marks in one place before moving quickly again.

- You can have a loose "blob" shape in mind when you begin, but ultimately your hand and subconscious will dominate the mark-making process.

- Once you have drawn your marks, turn the page around to see if you see an animal.

- Add an eye (or two!) and finish your drawing with a variety of textured lines—light, feathery strokes; darker dots; or cross-hatching.

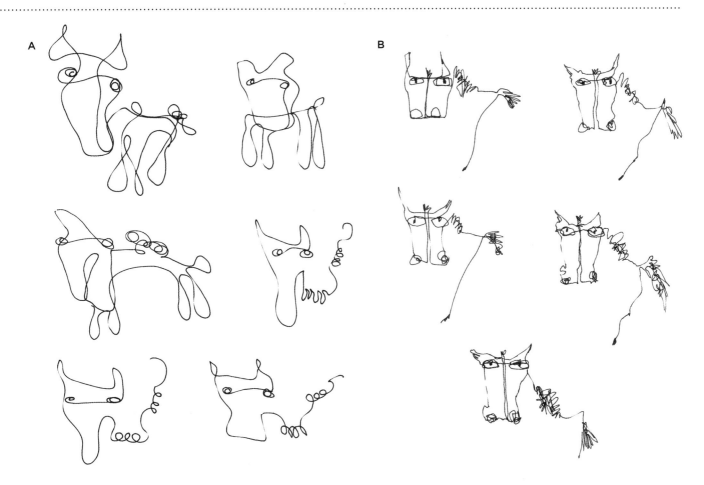

A

B

② Scribbly One-Liners. These draw-ings are done fairly quickly and in one flowing motion . . . and by using one line only. (Once you put pen to paper, you do not lift your pen until your drawing is complete.)

Gather five to ten pieces of paper and your pen or pencil. Decide on an animal and briefly consider some of the unique attributes of that animal. (For example, an elephant has a long

trunk, floppy ears, wrinkly skin, tusks, funny toes, etc.) Then, very quickly, draw it from imagination using one line only. Don't forget to get an eye in there.

It might take a while to get the hang of it, but by giving your sub-conscious the reins, you will come up with drawings you never would have thought of "on your own."

Start fairly quickly and do several

pages of one-liners until you hap-pen upon a design you like. (**A**) Then slow down for the next few pages and continue executing that same design over and over. (**B**) You will still move somewhat quickly, but not as quickly as before. Try keeping your hand very loose so that the natural shake of your hand comes into play. (This is a great exercise to do right after your morn-ing coffee!)

3 Jigsaw Puzzlers. In this exercise, you will scribble jigsaw-puzzlelike lines all over your paper. Once again, you are not thinking at this stage but just letting your subconscious guide your hand across the page. Then you will use your animal sleuthing skills to find birds, fish, and other creatures. Color as desired.

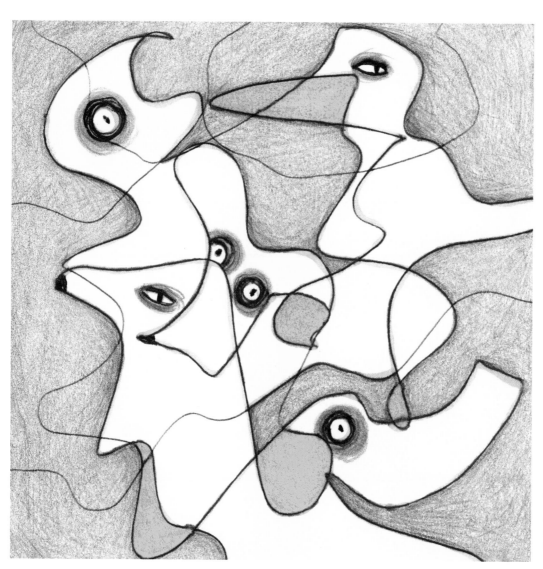

◀ While this might not necessarily work as a finished drawing in itself, it provides lots of fodder for future animal characters and paintings.

4 **Pastel Smears.** I like to rub Pan-Pastels onto paper with my finger, though regular pastels will work great too. Pick a color and smear some pigment on your page, working fairly small to start (about 4 inches [10 cm] maximum). Now pick up a second color and rub it on the page, moving it around the blob for balance. Add a third color if you wish.

Use your kneaded rubber eraser to pull off some pigment here and there, lightening some areas and rounding out a contour shape. Keep adding and taking away the pastel until a creature emerges and you have the impulse to add legs, ears, and so on. Black ballpoint pen works well with the soft pastels.

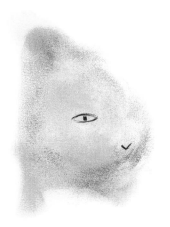
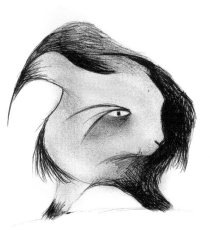

▲ This progression shows how an animal might emerge from random pastel marks. In this case, the ears kind of got away from me and the creature morphed into something kind of strange. (It's a good thing these are *imaginary* animals!)

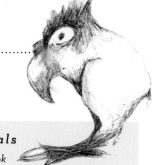

Start with an Eye

The one consistency in all my drawings is that I have no idea what I am going to do or what the animal will look like before I begin. (I've met other artists that are able to see finished drawings in their mind's eye, but not me.) I've grown to like the surprise element that comes with letting my animals develop on paper and now appreciate that I was given the "weakness" of not being able to foresee my drawings.

One thing I can manage to "imagine" is an eye, so one way I get started is to begin with an eye. From there, the animal emerges quickly, as my pencil is already moving.

materials
- *sketchbook*
- *pencil, charcoal, or ballpoint pen*

❶ Holding the pencil loosely in your hand, draw an eye. Stay loose!

❷ Now start to expand out from the eye. Perhaps you will draw a beak or a nose or another eye—or the shadow or fur right below the eye. Keep your pencil mostly on the paper during the earlier part of the drawing, so that your subconscious feels like it is doing most of the work. (Once you lift the pencil, you'll need to make a conscious decision when to put it down again.)

❸ Keep making marks until you have a clearer idea where the drawing is taking you. Once an animal is solidly started, you can safely lift your pencil and make more careful decisions on how to finish it.

❹ Try not to overwork! I often have a little "ping" moment that tells me when to stop working on a drawing. If I feel the nudge to stop, I do. I can always go back in later, but it's difficult to save an overworked drawing.

▼ Here are some one-eyed beginnings. Spend time playing around with different eye shapes and pupil placements to start to get a feel for how minute changes can completely change the expression of an animal.

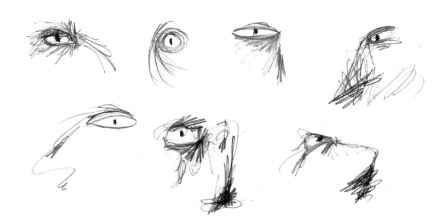

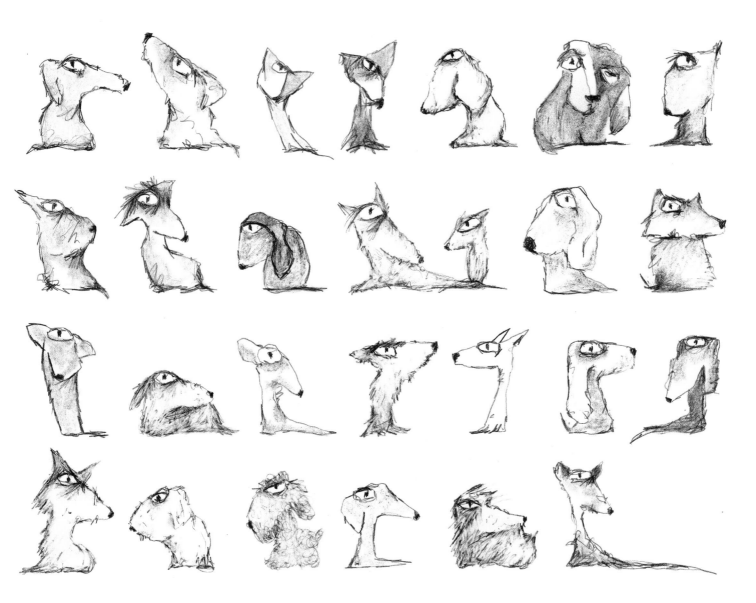

These grumpy dogs were developed with the one-eye trick using pencil and eraser.

Watercolor Blobimals

This exercise is one of my favorite things to do; my "go-to" when I'm feeling stumped at the studio table. It's also a fun way to get the hang of working with layers of transparent watercolor, which can add so much depth to your colors.

materials

- *watercolor paper or sketchbook*
- *#12 round watercolor brush (or similar)*
- *watercolors*
- *pencil or .01 micron pen (or similar)*

❶ Mix up a very light hue of a color of your choice, and paint a blob shape from your imagination. I like to start with a circle for the eye and work out from there. Work fairly small, about 2" x 2" (5 x 5 cm). Try moving the paint around, almost in slow motion. This gives you time to think of little bumps and details to add to your shape.

❷ Keep in mind that you will end up with an animal (though it's unnecessary to know what kind it is at this point). Still, think "ears," "legs," and so on. Let dry.

❸ Mix up a second color, very light. (I often use brown or yellow.) Paint over the first color with the second layer. Let dry.

❹ Using a pencil or ink pen, add eye details, fur, shading, or outline to complete your imaginary creature. If desired, add layered textures to your blobimals with colored pencils and markers (see exercise #2).

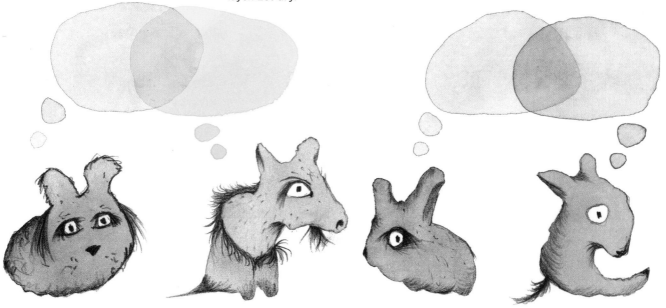

▷ When laying down your paint keep your hand loose so that your edges are imperfect. Your paint should be quite wet.

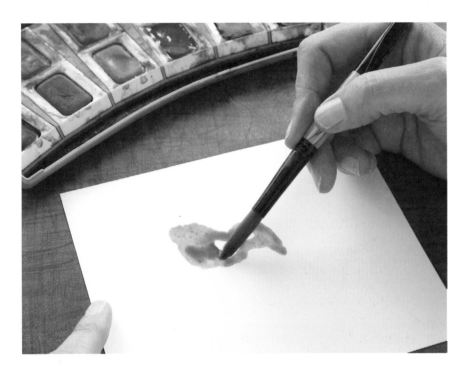

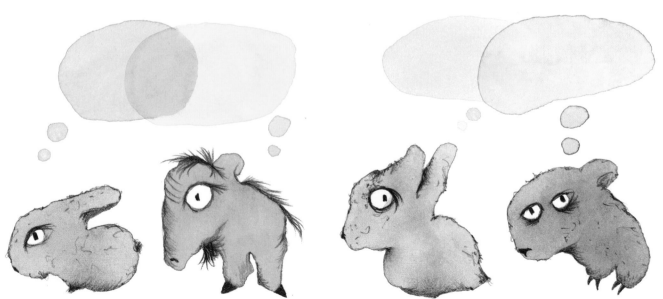

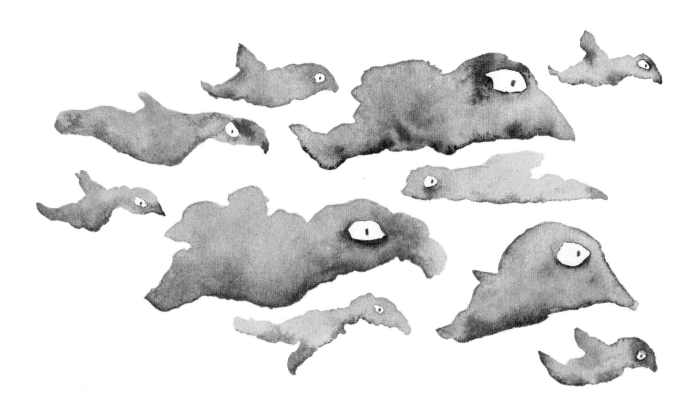

▲ **Punch Up the Pigment.** These birds were created by dropping in some concentrated pigment around the eyes and on the bottom edge of the birds while the first layer of watercolor was still wet. This is one page of an ongoing project: an entire book of just blob birds.

▼ **Marbling.** Add white acrylic ink while the watercolor is still wet for a marbled effect. It might take a little practice to get the hang of it. Apply ink with an eyedropper directly in the wet (but not *too* wet) watercolor.

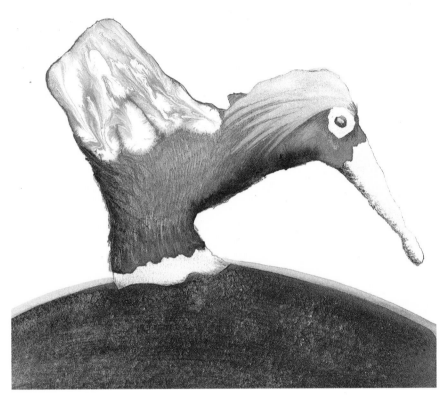

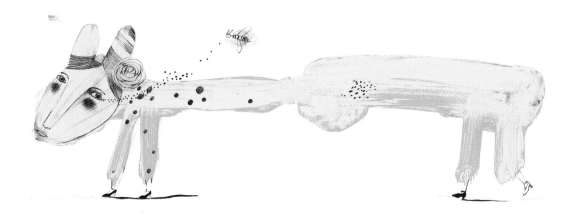

How Long *by* Marina Rachner
acrylic and pencil on paper

"This picture formed when I tried to get rid of excess paint, i.e., a swift and uncontrolled brushstroke. Spontaneously I added the head with ears and the legs and used a well-sharpened pencil to draw the gentle features."

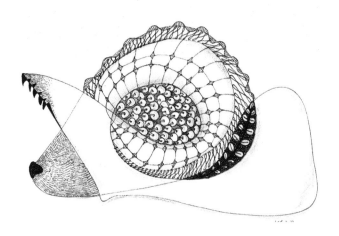

Phishing Bird *by* Dar Hosta
Pitt pens, Prismacolor markers, vine charcoal, and acrylic ink on paper

Children's book author and illustrator Dar Hosta likes to add little conversations and rants to her series of cranky birds. "As a graduate of The Art of Silliness, I became obsessed with blob animals. Strangely, all the blobs turned into birds—not cute, fluffy, feathery birds that peck seeds and build nests, but ugly, ranting birds that complain about everything. Pretty soon, Cranky Birds was born. You might think I am a cranky and complaining person but, I swear, it's not me. It's the birds."

Snail-Dog *by* Lisa Firke
pencil and black ink pen on paper

Lisa often likes to begin a piece with an abstract, looping line. She says, "Make sure this crosses itself and ends up connected back up to the beginning. Then just start filling in the areas created by the lines until something emerges—in this case, a snail-dog."

2 Mixed-Media PROJECTS

PAINTINGS, ARTIST'S BOOKS, AND OTHER FUN STUFF

All the exercises in the previous chapters will come in handy as you start working through the projects in this section. I've tried to make the step-by-step directions clear and straightforward; however, if at any time you have an impulse to take the project in a different direction, I hope you will follow that impulse!

Art instructor Lucile Blanch writes, "A painting idea is never complete before the artist starts to paint . . . [T]he material will assert itself, the hand will deviate, the mind will change—the experience has already shown the way."

The same is true for any creative undertaking. It's unlikely—and undesirable even—that your finished projects will look anything like the pieces shown here. Your personality will enter the process, and your pieces will have your unique stamp on them—and that is a very good thing!

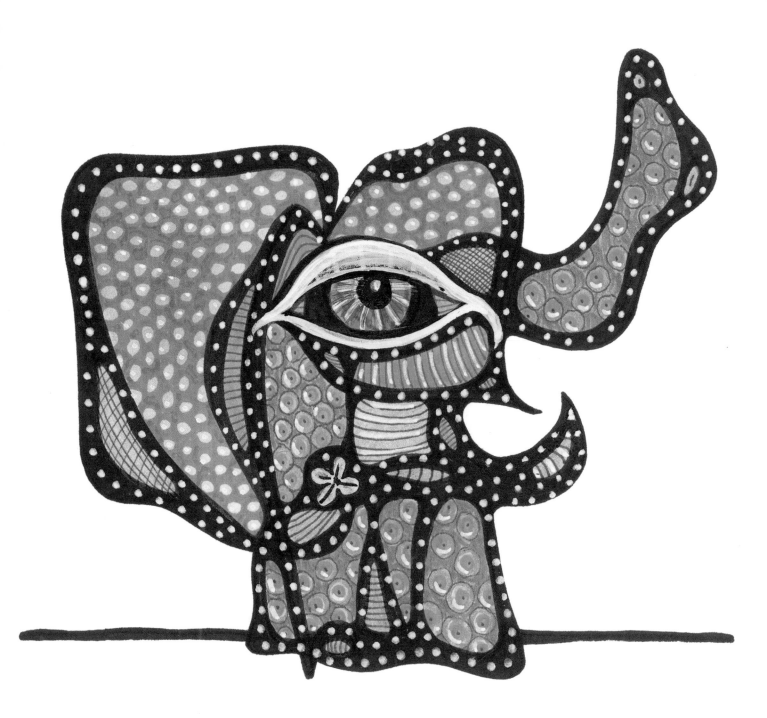

4

Oaxacan Dotted Elephant

More Is More

"Excess on occasion is exhilarating. It prevents moderation from acquiring the deadening effect of a habit." —W. Somerset Maugham

This exercise is inspired by the wonderful contemporary animal carvings from Oaxaca, Mexico.

My natural tendency is to work very simply, with limited supplies; some of my favorite pieces ever are drawings done with a single piece of charcoal! At the same time, I admire the rich, layered artwork of so many of my mixed-media friends and the way they pile the media on: colored pencils, markers, charcoal, graphite, paint Looking around one day for something to get me moving in this direction, I decided this little grasshopper wood carving from Oaxaca would provide excellent inspiration.

As with most things, it only served as a jumping-off point, and in no time, I was immersed in the meditative fun of making an over-the-top (for me) mixed-media piece!

materials

- 8.5" x 11" (21.6 x 27.9 cm) sheet of hot-press watercolor paper
- black permanent markers
- very-light-colored markers (water soluble or alcohol based)
- colored pencils
- white paint pen
- optional: scanner and printer

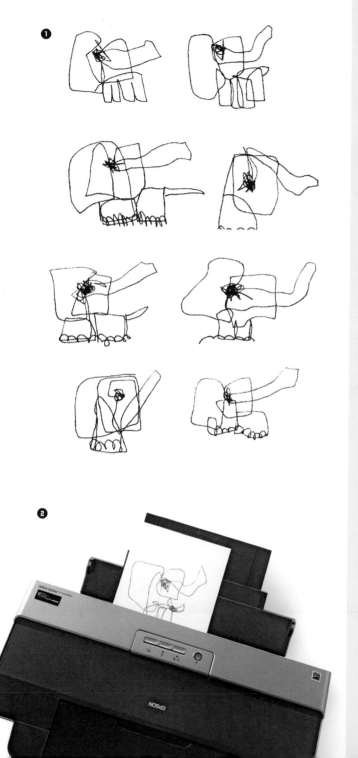

❶ Draw eight to fifteen small elephants. These little scribbly one-liners were created quickly over several pages of my sketchbook before I finally made the one I wanted to take further.

❷ Pick the one you like best (and provides the most opportunity for embellishment) and scan it into the computer. In your photo editing program, enlarge the elephant to fit nicely on an 8½ x 11 inch (21.6 x 27.9 cm) paper and print. (I printed on 140# Fabriano hot-press watercolor paper.)

When feeding heavier paper through standard ink-jet printers, you will need to "help" it along. Basically, I apply a little pressure to push the paper gently so that it catches. It might take a few tries, but I've been able to print on papers up to 140# this way. Smooth drawing or watercolor papers (hot press) typically print a little better than rough (cold press) papers.

Alternatively, you can draw your design directly onto your larger paper.

❸ With a black permanent marker, play with adding weight and whimsy to the existing lines. Thicken here and there, round corners, and add more lines, if desired. Play! Fill in so that your elephant has a nice balance of thinner and thicker lines.

❹ Color in some of the spaces with a transparent layer of watercolor, using several colors for this first layer.

❺ Using markers and colored pencils, add multiple layers of color to your drawing with lines, dots, and patterns until you are pleased.

❻ Finish with a white paint pen. Dots are an important distinguishing element of the Oaxacan carvings; add dots along the black lines and any other place you feel needs a little white. Done!

3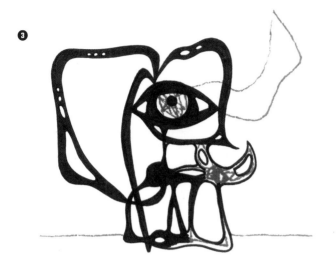

4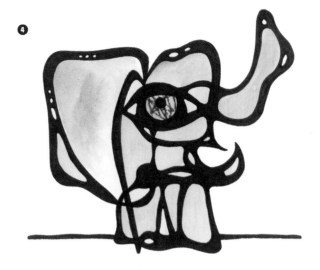

5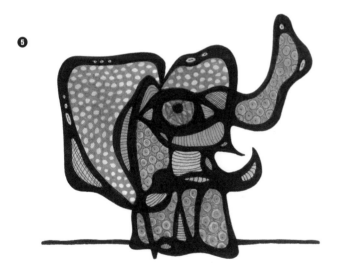

6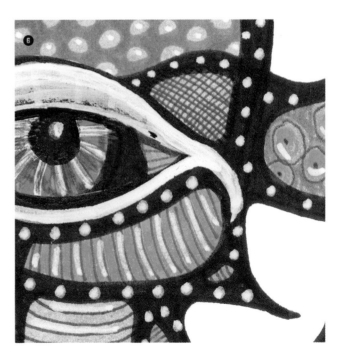

tip ▶ Rather than use a white paint pen, you can use watered-down gesso or white acrylic ink and apply your white detailing with a very thin liner brush.

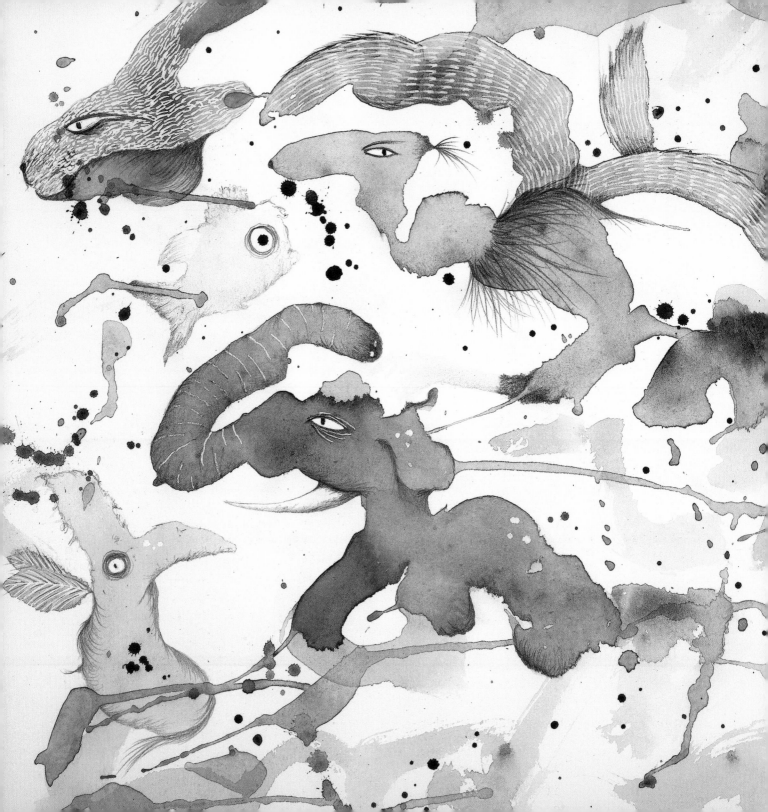

5

Imaginary Animals

Abstract Watercolor Starts

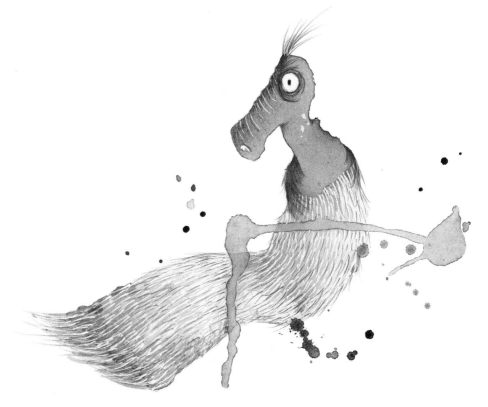

Sometimes you need to figure out ways to work around your natural tendencies if you want different results.

I tend to be neat and precise (some would say "tight"), especially after I've spent a fair amount of time on a drawing: I start to lose courage and don't want to "mess it up." For this reason, I often intentionally "mess up" the piece first thing, and in this case, with random watercolor marks.

Starting in this manner is a freeing way to work. You just splatter the paint on the page with little thought as to outcome. Work fast. Put on music if you like. Paint several pieces of paper at one time.

Later you can put any neat-freak tendencies to work with more controlled drawing and painting additions.

The animals on this page were created with blue and black watercolor, pencil, and a white paint pen.

materials

- *sheet of 11" x 15" (27.9 x 38.1 cm) hot-press watercolor paper*
- *watercolors*
- *large round brush*
- *pencil*
- *white paint pen*
- *optional: acrylic ink*

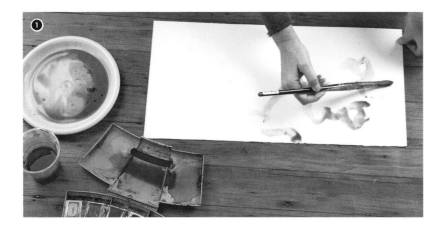

❶ Premix several transparent colors in your palette. (Your paint color should be pale, as later we will add more paint, markers, colored pencil, and other media to flesh it out.) Since you are working with a larger sheet of paper, use a large brush and mix enough color so you don't run out in the middle of painting. And remember to use lots of water!

❷ Tip the page so that the paint spills into irregular lines and splatter the paint by tapping the end of your paintbrush. Let dry completely.

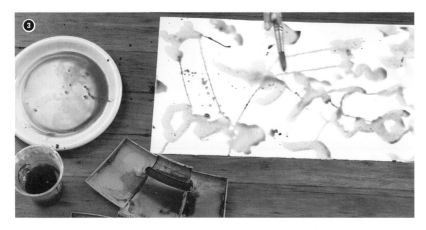

❸ Add a second color, then continue to randomly lay down curved lines and splatters, aiming to balance the colors around your paper. Also, leave at least 50 percent of the paper white (important!). Once you have your transparent colors in place, go back in with more concentrated pigment and drop it into your still-wet (though not sopping-wet) paint.

❹ Pull out and embellish your imaginary animals with pencil, markers, colored pencils, a white paint pen, and so on.

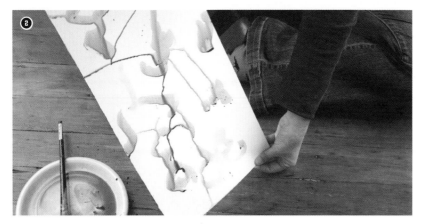

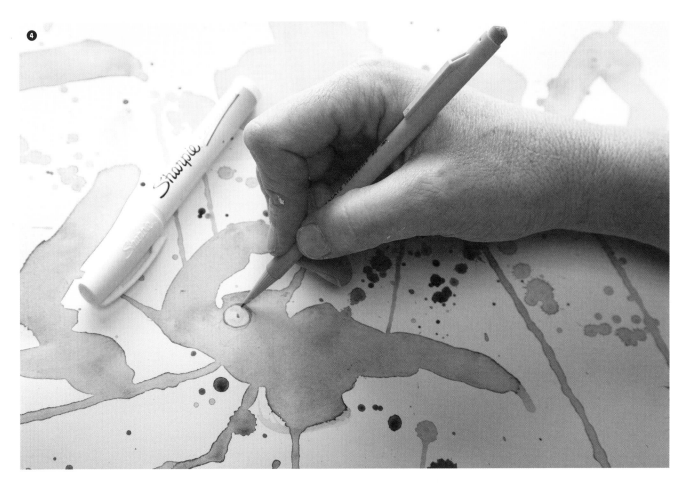

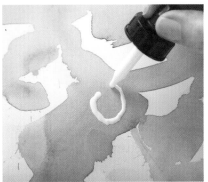

tip ▶ Another way to add texture and interest is to add detailing with white FW acrylic ink applied directly with the eyedropper. This makes for a thick, less-controlled, clunky, and crackly line. (But make this your last step of the day; it takes a while to dry!) Spray to protect.

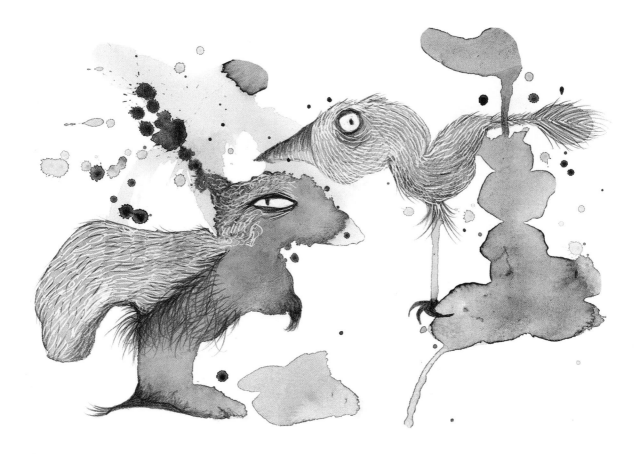

Clean It Up Digitally. Scan a portion of your image into the computer and use your photo editing program to remove some of the splotches. Round the corners on others so that they seem natural. Print on watercolor paper.

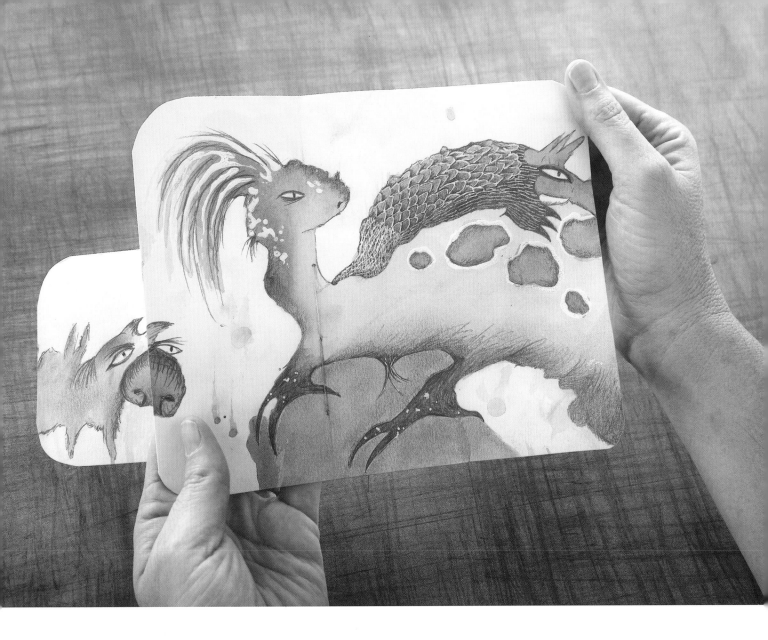

Make an Interactive Book. Make into an artist's book where the creatures on each page interact and connect with art on previous pages (see the next chapter for more on this). Paint your pages as instructed, but on both sides of your paper. Cut down to two or three long pages, fold, bind together, then finish as usual.

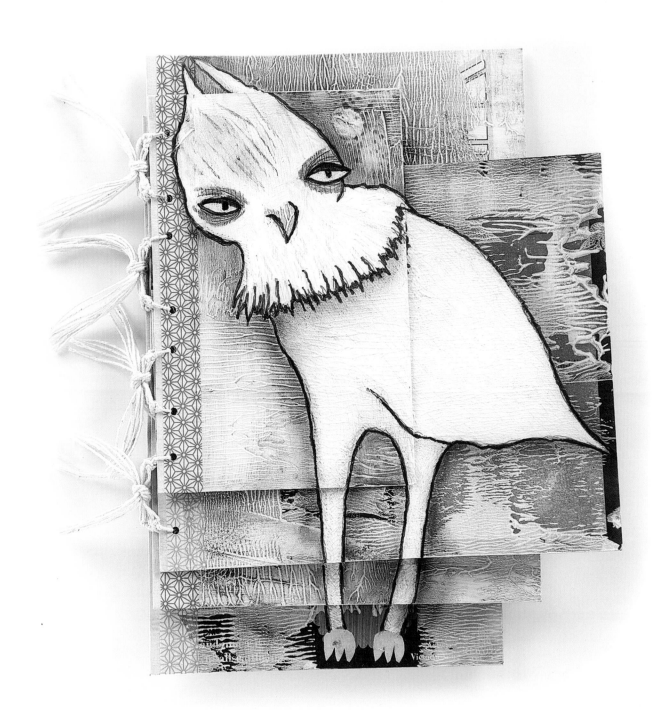

6

Junk Mail Creatures Book

Gesso and Watercolor

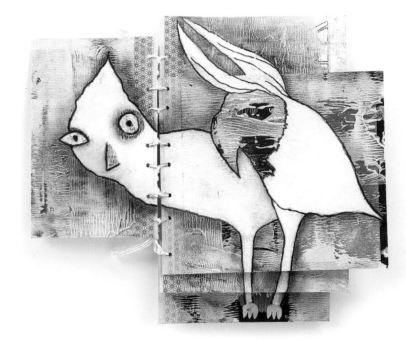

A MONKEY MIND

This term refers to a mind that jumps from thought to thought like a monkey jumps from tree to tree—and is definitely a weakness when it comes to certain things.

(Seriously, is it really necessary for squeaky brakes, cat food, laundry, spiders, dead flies, deadlines, traffic, student drivers, walks, slow-runs, swims, showers, baths, and nail biting to cross my mind when all I want to do is write a simple paragraph intro for this chapter, for example?)

Weaknesses in our personalities and abilities can make our lives more difficult, yes. And yet, consider the following statement about a contemporary Indian artist:

"All his weaknesses were his strengths."

This project embraces that nonlinear-monkey-mind "weakness" part of us. Tangents? You are welcome here!

In this puzzlelike book, each successive drawing interacts with and is part of the previous page's illustration.

materials
- 5 to 7 junk mail postcards
- white gesso
- string
- watercolors, small paintbrush
- colored permanent markers
- soft vine charcoal
- spray fixative
- 1/8" (3 mm) hole punch
- brayer
- masking/decorative tape
- rag for rubbing and buffing

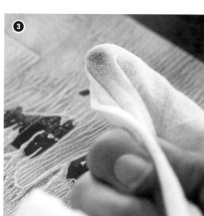

❶ Gather five to seven junk-mail postcards 4 x 6 inches (10.2 x 15.2 cm) or larger. This project works best with many different sizes of postcards. Roll your brayer through a dollop of white gesso, making sure the paint is loaded thickly. Now, with a very light touch, roll your brayer across the surface of a postcard. (You are kind of skimming the top of it.) You might need to do a second pass, but don't rub and rub; one or two passes is all you need. There should be color from the postcard showing through. Set aside to dry; repeat with other postcards. Gesso both sides.

❷ Once your gesso is completely dry, add a very wet, transparent layer of watercolor using a color of your choice. In this case, I used a blue-green. Let dry completely before adding a second layer of transparent watercolor. (I used brown and orange.) Repeat on the fronts and backs of all postcards. Let dry.

❸ Because the gesso resists the watercolor, your paint might have dried in puddles. In this rub-and-buff step you are going to both spread around the pigment, unifying the piece, and also lift the color off the raised portions of the gessoed texture. Wrap your rag around your finger, dip it into water, and squeeze off the excess so it is just slightly damp. With a light touch to start, rub the rag on the top of the postcard in a circular motion to start moving the pigment around. As the rag gets drier, you can apply more pressure. Keep rubbing and buffing until you are satisfied with the texture.

❹ Next, you're going to design your irregularly shaped book. Cut down several postcards so that you have a variety of sizes to work with. Spend some time arranging them into a design that is pleasing to you, making sure that the pages are not aligned perfectly, but are irregular.

tip ▶ With the rubbing and buffing, each color reacts a little differently. Blue, black, and orange watercolors tend to darken after rubbing; yellow always brightens up a piece; and brown will mute your colors. You will need to just experiment and keep working at it until you find combinations that you like!

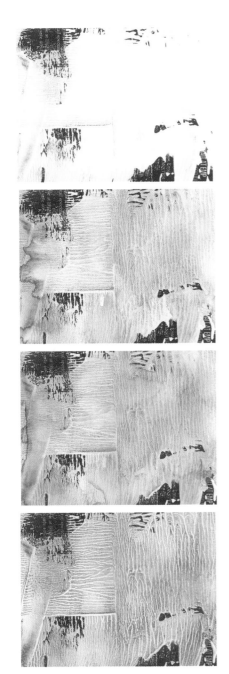

This series shows a progression of textures after steps 1 through 3.

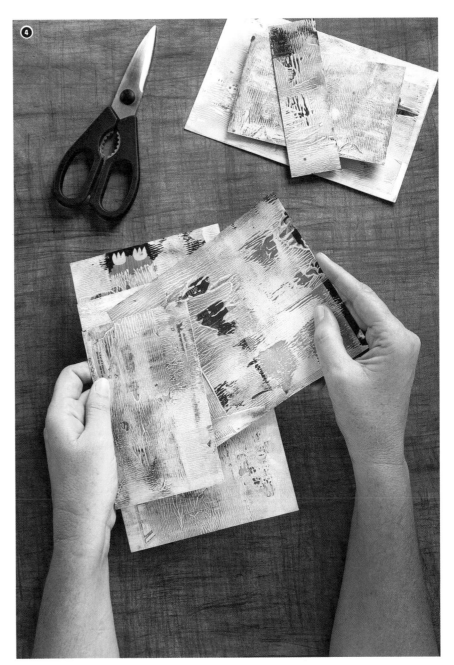

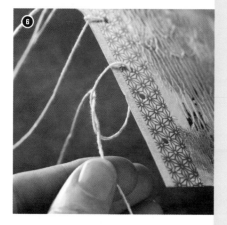

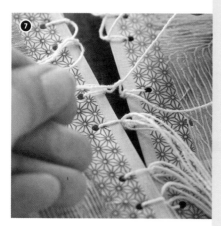

5 Once you are satisfied with the layout of your book, reinforce the spine edges of each page with masking and/or decorative tape. Use a ⅛-inch (3 mm)-hole punch to make three to seven holes in your top postcard. (They do not need to be evenly spaced.) Using your first postcard as a template, punch holes in the other pages.

6 Cut a piece of string about 8 inches (20.3 cm)-long for each hole. Using a square knot, tie one piece of string through each and every punched hole.

7 Connect the pages by placing two pages together and tying the middle strings as shown. I usually do this binding portion with the pages placed between my knees to hold them still. Once all your square knots are tied, you can add beads, braid them, or trim your string short.

8 Now you are ready to draw. Using a colored, permanent marker (or a pencil to start, if desired), draw an animal. Refer to your sketchbook for ideas or try to see an animal in the textured pages and finish that. Make sure part of the drawing spills over onto a page or pages underneath.

Then, when you turn the page, you will have something already started on the next spread that you will then complete. The end goal is a puzzle-like book where each illustration interacts with and is part of the previous page's illustration.

9 Once you have your animals blocked in, fill in your animals with a layer of gesso. (The white paint will give your eye a rest and provide a nice contrast to the textured backgrounds.) Let dry completely.

10 Go back with your colored marker and redraw any lines you may have obscured with gesso, keeping your hand loose. Then add cross-hatching, shading, or any other details you like with thinner markers.

11 Add vine charcoal shading around the edges of your animals to make them stand out even more. Apply directly onto your drawing and then rub the charcoal with your finger to soften. Spray with fixative.

tip ▶ Depending on your brand of gesso, you might find that your permanent markers get clogged a bit when drawing on top of the gesso. Keep a piece of scratch paper handy to work your markers out or spray the pages first with a fixative and then draw.

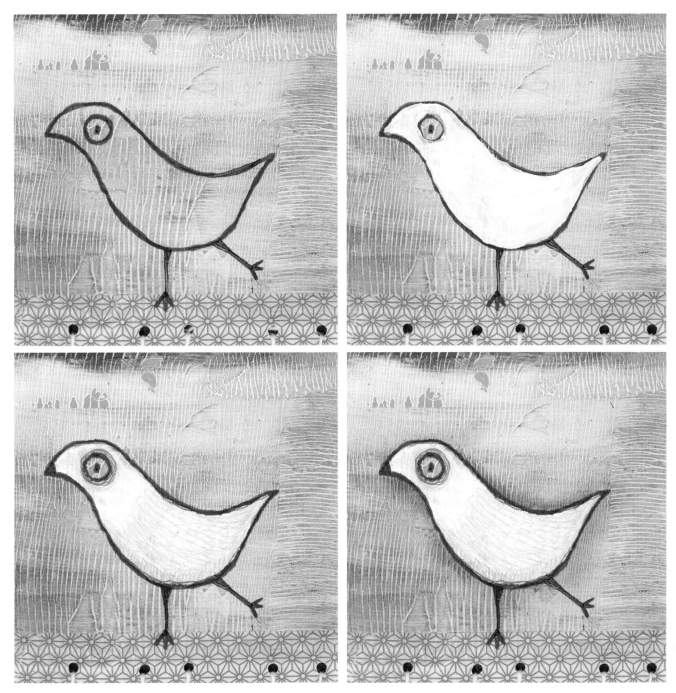

Steps 8 through 11

7

Watercolor Transfer Animals

Iron-ons

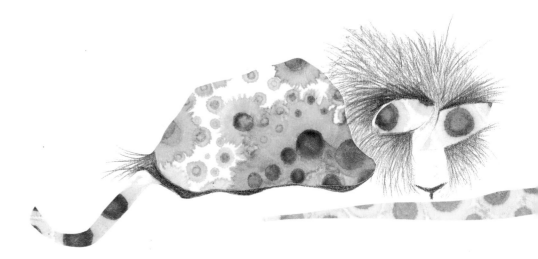

ACCIDENTS AND MISTAKES CAN PLAY A LARGE ROLE IN YOUR ART-MAKING WORLD.

A few years ago, I was making and selling fabric transfers of my artwork using T-shirt transfer paper. A printed page was sitting on my studio desk waiting to be ironed onto fabric when I accidentally splattered some watercolor on it; the way the paint reacted was really cool! I began experimenting with painting on transfer paper and then ironing it onto watercolor paper and fabric. I tested other media and started to layer the transfers on top of each other, which resulted in a process similar to relief printmaking.

For this project, we will create creatures two ways using watercolors, transfer paper, and an iron!

In this chapter, we'll experiment with this easy and quick technique that creates some of the loveliest watercolor textures I've seen.

materials
- *sheet of 8½" x 11" (21.6 x 27.9 cm) hot-press watercolor paper*
- *package of cold-peel T-shirt transfer paper for light fabric*
- *piece of tissue paper (or similar)*
- *watercolors*
- *#12 round watercolor brush or similar*
- *iron*
- *optional: soft vine charcoal, ballpoint pen, pastels, markers*

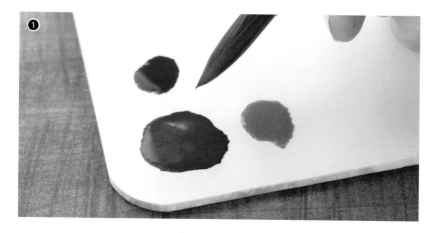

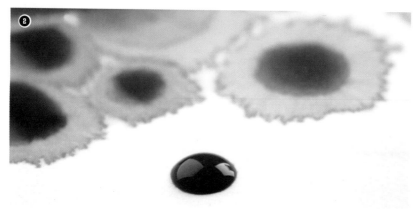

PAINTING YOUR TRANSFER PAPER

1 Mix up a medium-hued color using at least two different colors of paint. (When the paint reacts to the chemicals on the transfer paper, often the colors you used will separate out, enriching the colors.) Light to medium colors work best, and your paint should be quite wet.

2 The water will spread out from your initial paint stroke. Apply paint slowly as you begin until you get the hang of how the paint reacts to the paper. When you drop on dots for circles, it will look like a normal dot, but after a few moments, you will see the water spreading out. If your paper gets too wet or starts to look muddy, stop. Let dry and then begin again. Let dry completely.

3 Once dry, you can add other media such as ballpoint pen, markers, Copics, soft vine charcoal, and pastels for texture and variety.

tip ▶ Some media are *not* suited for transfer paper, as they are too hard and might tear into the plastic coating or the coating reacts to the pen and clogs it up. Here's a partial list: pencils, colored pencils, and some permanent and felt-tip markers. Also, some ballpoint pens may fade or change colors over time.

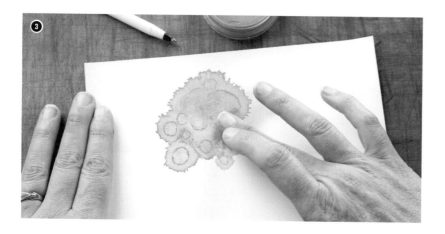

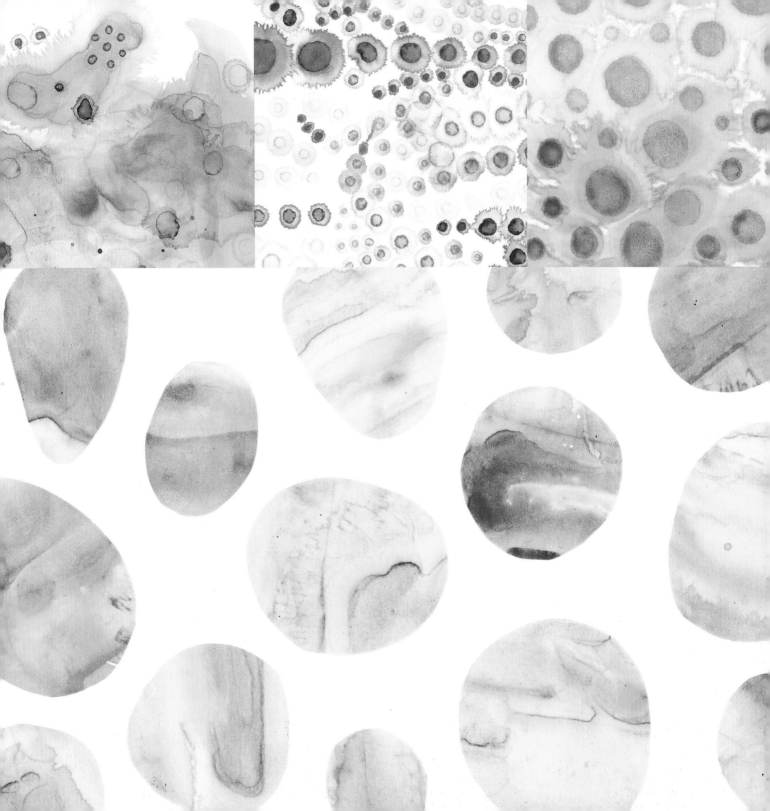

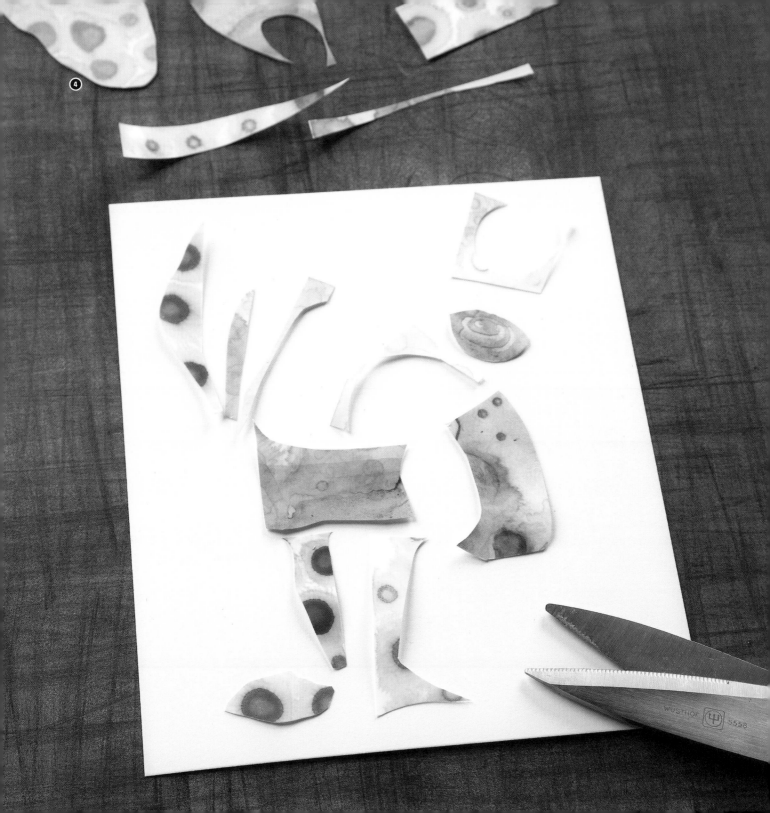

4 Next, you will cut out your papers to "build" an animal shape. You will create your design on a scrap piece of paper, which will serve as a temporary base for your design.

5 Once you have a design you like, place your watercolor paper on top of your design, making a paper "sandwich." Using both hands (fingers spread out for stability), place one hand below and one hand above and turn over.

6 Carefully lift the top paper off. Your original design is now reversed, and the watercolored side of the transfer paper is now facedown on your watercolor paper. You might need to reposition a few pieces that shifted during the flip.

7 Preheat the iron to the cotton setting. Place your watercolor paper on a firm surface such as a tabletop, protecting your table with pieces of mat board, if desired. Place a piece of tissue paper over your pieces and iron following the package instructions (usually 30 to 60 seconds). Let cool and peel off the backing. Draw or paint additional detailing, if desired.

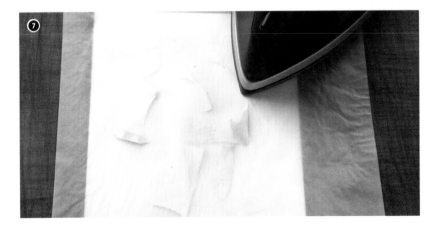

tip ▶ When ironing on paper vs. fabric, the transfer may slide around once heated, smearing your design. To avoid this, just apply straight-down pressure with your iron, being very careful when you lift not to bump the transfer while it is still hot.

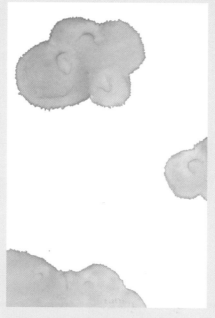

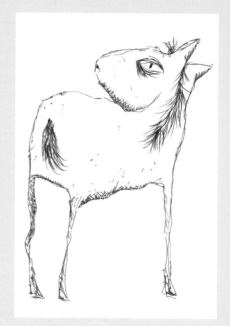

ALTERNATE METHOD: LAYERING TRANSFER PLATES

Another fun way to work with transfer paper is to create different layers, or "plates," and then iron them on top of each other. The paper is transparent when applied, and you will be able to see through all the layers.

❶ Start with three papers that are identical in shape and size. Add watercolor, charcoal, or other media to each of your plates. Try to place the elements so that they will interact and overlap a bit. Note: I tend to let this be an "eyeballing" step, knowing that the end result might be different than I anticipated. (I've learned that happy accidents often provide better results than when I'm too controlled. Also, it keeps the mystery alive; I'm never quite sure what the finished piece will look like!)

❷ Iron your first transfer onto your watercolor paper or fabric. Let cool, peel off the paper backing, and repeat by carefully placing your second transfer over the first layer. Repeat a third time.

tip ▶ If you make a mistake and lift the transfer paper before it is completely set, you can try replacing the backing carefully and ironing again. If you still have bubbles or other "tears" in the transfer, you can hit it carefully with a heat gun to smooth out the plastic.

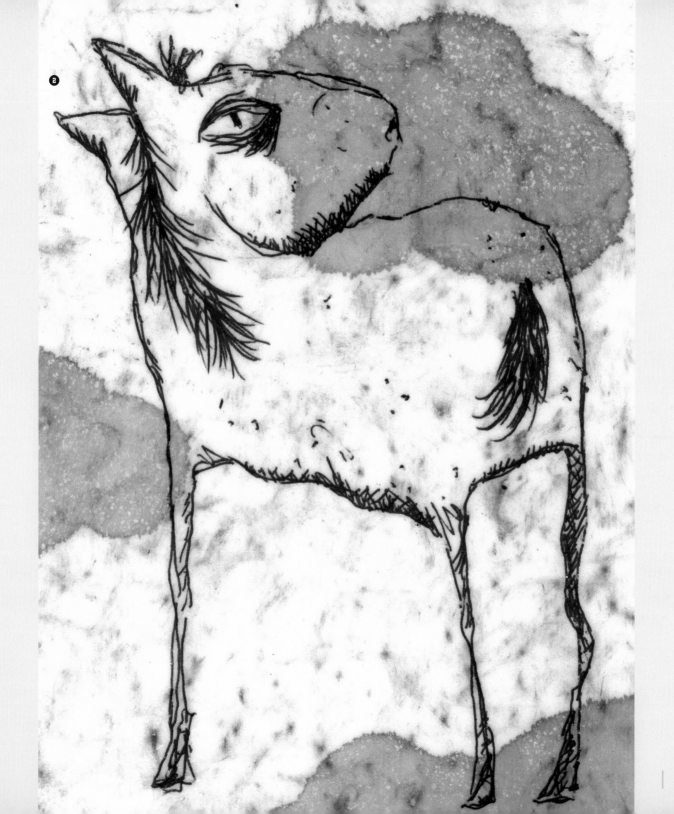

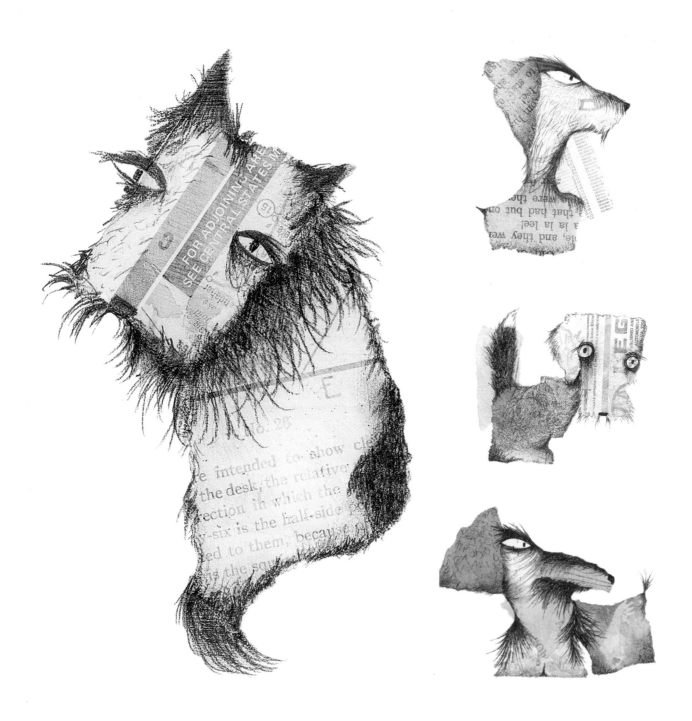

8

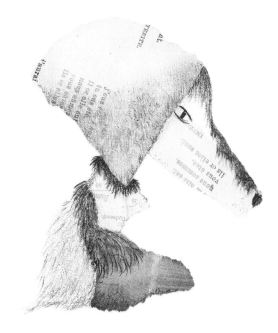

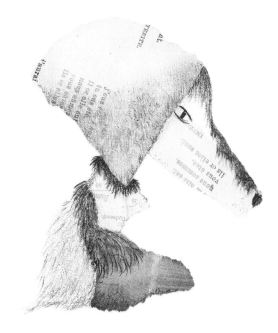

PROJECT

Doggone It!

Messy Collage

COLLAGE AND DRAWING

I love the look of paper collage incorporated into drawings and paintings but find I avoid pulling out gel medium or even a glue stick. (I guess we just don't get along.) However, I recently took a class from Oregon artist Karen O'Brien and, after seeing some of her richly layered journal pages was inspired to get over myself and give it a try. This project consists of creating a series of dogs (or animal of your choice) by gluing down random pieces of collage papers, covering them with Golden Absorbent Ground, and finishing with a mechanical pencil.

This project is easy and quick (and the messy part only lasts a few minutes).

I don't like to get my hands messy and will rarely pull out the glue. But there are always exceptions, and this series of dogs was one of them!

materials

- 6-10 pieces of hot-press watercolor paper, about 4" x 5" (10.2 x 12.7 cm)
- gel medium
- application brush
- Golden Absorbent Ground
- mechanical pencil
- kneaded rubber eraser
- stump

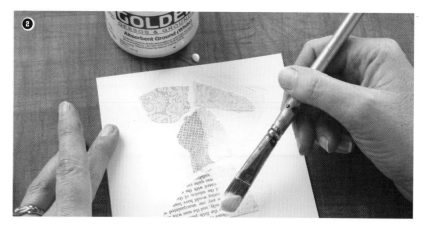

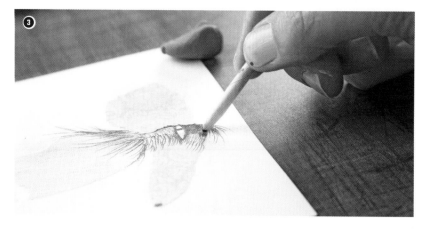

❶ Find some collage ephemera you like and tear them into smallish pieces (about 1½ inches [3.8 cm]). Here I used a page from an old book and some security envelopes. On each page, glue down onto three or four pieces with gel medium. (Though this step is "random," in the back of your mind you should be aware that you eventually want to make an animal, meaning you can generally place a "body" and a "snout," knowing that the parts might change down the line.)

❷ Cover your entire paper with a coating of absorbent ground. This will do two things: the creamy white substance tones down the colors of the collage papers, allowing you a more neutral surface on which to work, and it unifies surface textures of the different papers, so your pencil reacts the same no matter which part of the paper you are drawing on.

❸ Once everything is completely dry, add eyes, hair, paws, tails, fur, or other detailing to pull out your dog with your mechanical pencil. Use your stump to get into some of the nooks and crannies. Erase as needed.

tip ▶ Be aware that it's a little more difficult to erase pencil lines completely when working on the absorbent ground, so you might want to work lightly at first.

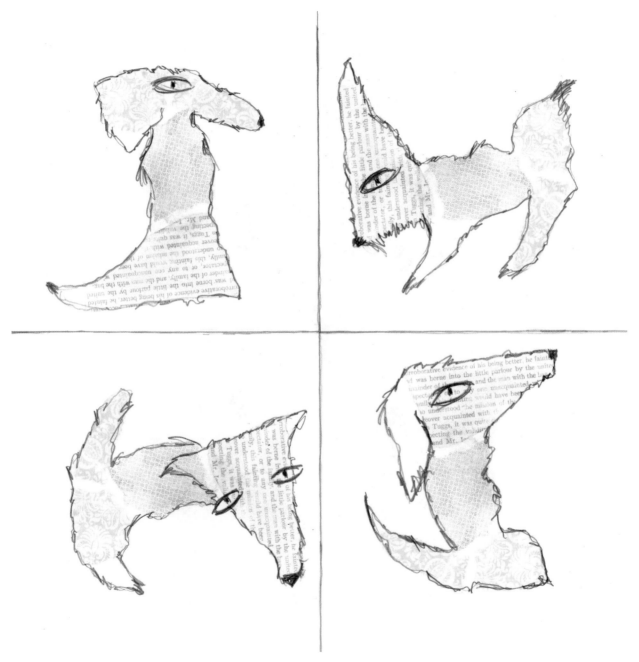

Here the collaged configuration, left, is shown in all four directions to show that once you get the hang of finding creatures in shapes, you can almost always make it work!

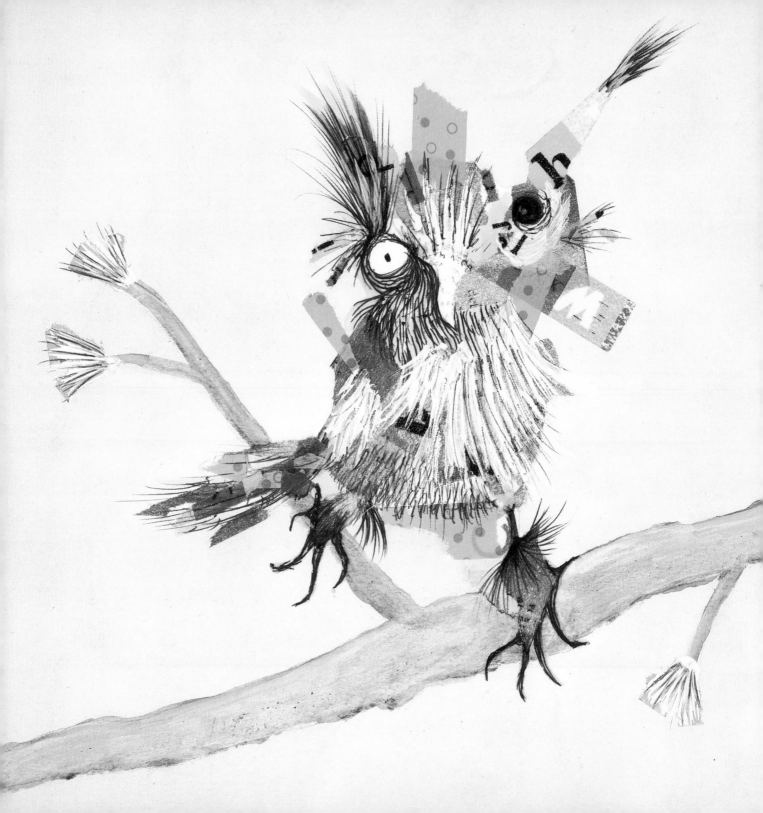

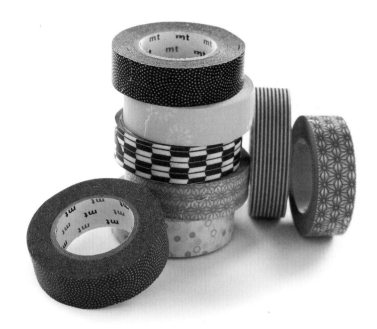

9

Animals in Tape

Instant Collage

PLAYING WITH DECORATIVE MASKING TAPE

Recently, I splurged and bought some Japanese Washi masking tape, and my glue issue (see previous chapter) was suddenly moot. Tape sticks easily, comes in beautiful colors and patterns, and can take a beating. Instant collage!

In addition, the narrow shape of masking tape has the benefit of providing a restriction or limitation that I've found so helpful in getting me started. I've found filmmaker Federico Fellini to be correct when he said, "I don't believe in total freedom for the artist. Left on his own, free to do anything he likes, the artist ends up doing nothing at all."

In this project, you can work intuitively as I show here, without a clear idea at first of what animal you are going to create. Alternatively, you can begin the project with your animal in mind and work either from your imagination or a reference.

Decorative masking tape is an easy way to add collaged elements into a piece without the mess of glue!

materials

- *watercolor paper, size of your choice*
- *assortment of decorative masking tape*
- *black ballpoint pen*
- *light gray alcohol-based marker*
- *white gesso*
- *paintbrush*
- *soft vine charcoal*
- *spray fixative*

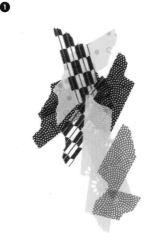

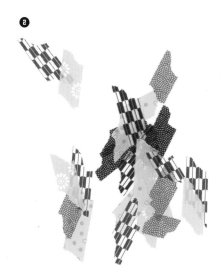

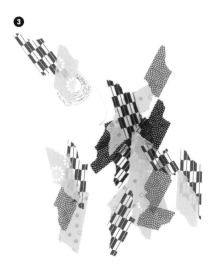

❶ Gather your materials. Tear off several pieces of tape approximately 1 inch (2.5 cm) long and place randomly on your paper. Tear off more tape of a different color/pattern and place it on your paper, overlapping some of the tape already in place. It's best at this point not to overthink.

❷ Continue with more tape, adding one or more colors to the mix. Move the colors around the page so that it remains balanced with darks and lights, colors, and so on. Pretty soon

an animal just might present itself to you. When you know where you're going (at least in terms of what kind of animal), you can add even more tape, solidifying your choice. You might also need to lift back off some pieces of tape that are working against your animal choice.

❸ With a black ballpoint pen, start drawing in eyes, feathers, fur, feet, and other details. Remember to keep your hand loose and vary your line pressure for interest and texture. Draw both on and off the tape.

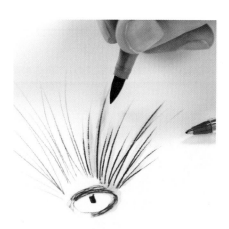

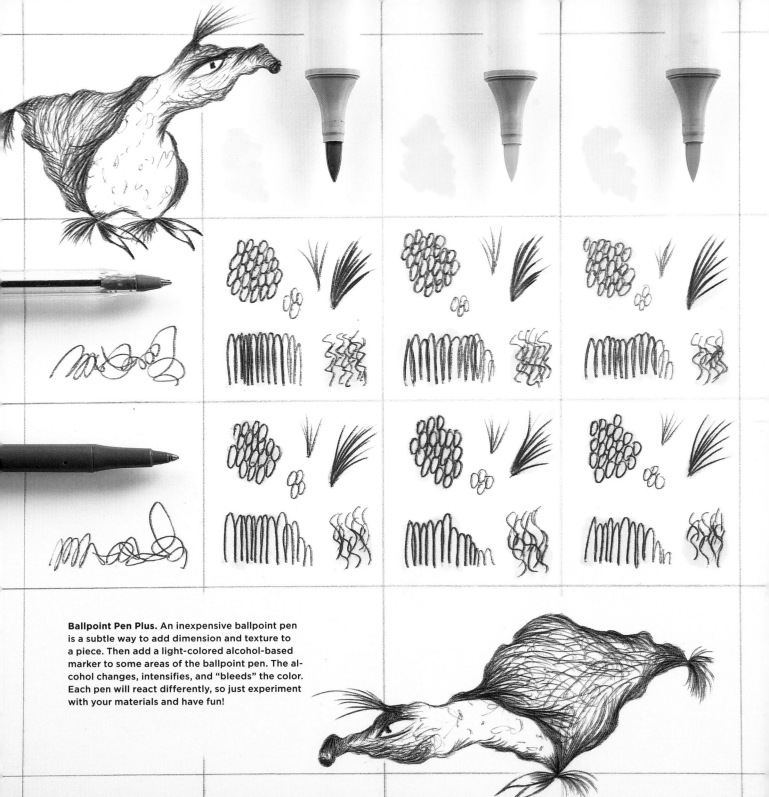

Ballpoint Pen Plus. An inexpensive ballpoint pen is a subtle way to add dimension and texture to a piece. Then add a light-colored alcohol-based marker to some areas of the ballpoint pen. The alcohol changes, intensifies, and "bleeds" the color. Each pen will react differently, so just experiment with your materials and have fun!

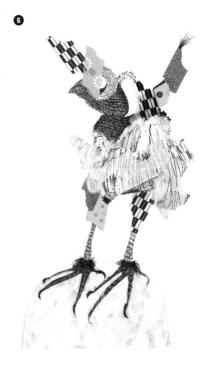

4 *S*mear selected areas of the ballpoint pen using a light-colored alcohol-based marker (such as Copic). Use the brush end of the marker with a very light, feathery touch. Ballpoint pens will react differently, depending on the brand.

5 *Optional step:* Work in multiple layers of watercolors and marker to add environment. In this case, I used two transparent layers of watercolor (gold and red) and then a gray Copic for the spots of the rock.

Now take stock of your piece. The piece just felt too busy at this point . . .

6 . . . so I added some white gesso with a dry brush. On the owl, I add clumps of gesso fairly thickly and then use the end of the paintbrush to make fur marks (and reveal the colored tape underneath).

7 Add vine charcoal and smudge with your finger for shading. Usually there is a natural stopping point where I'm not sure what to do next. I'll put the piece aside and wait a day or two so that I can come at it with fresh eyes. Then I might add more tape, ballpoint pen, Copic marker, gesso, or charcoal until I am satisfied. Spray with fixative.

tip ▶ Tape can be laid on top of the gesso to add color back or you can place it on top and then lift it up, which often will lift up the white gesso below and show the lower layer of colored tape.

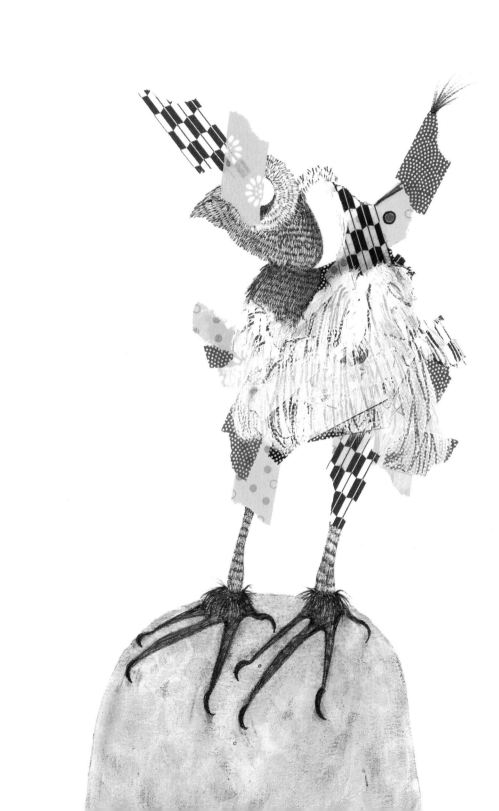

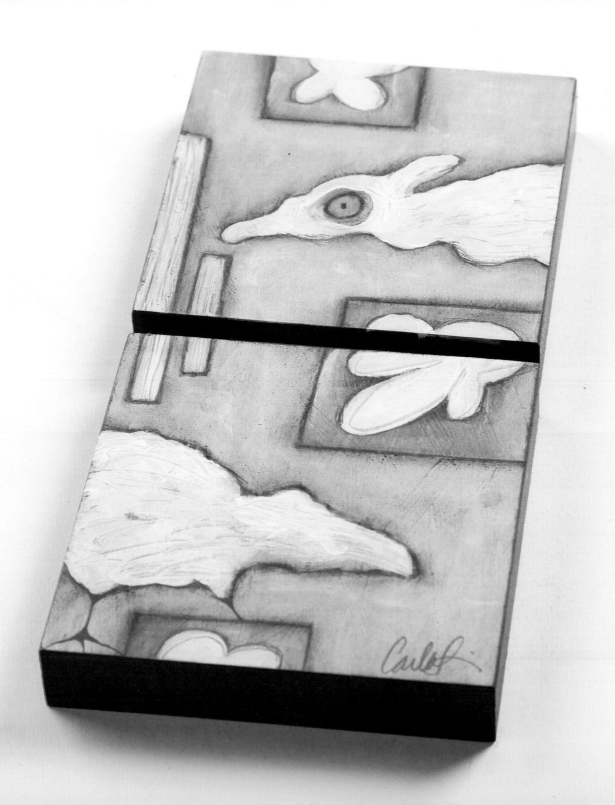

10

Creatures on Wood, Part I

Puzzle Paintings

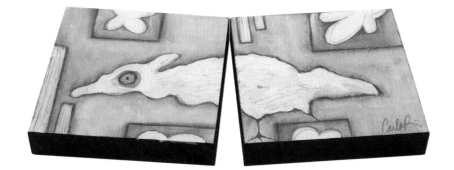

THIS DIPTYCH PAINTING IS FUN TO MAKE BECAUSE IT "WORKS" WHEN DISPLAYED IN ALL FOUR DIRECTIONS.

Start by placing the two wood substrates side by side horizontally and drawing an animal lightly in pencil. Make sure it goes across the two. (You can use drawings from the exercises in the first section for inspiration if you get stuck for ideas.) Then move your paintings so they are stacked on top of each other and add an element (animal or otherwise) to connect the two pieces when placed this way. Repeat a third and a fourth time.

Who says paintings can't be puzzles?

These paintings can be displayed on a tabletop rather than a wall to encourage interaction and play.

materials
- 2 pieces of wood (about 5" x 5" [12.7 x 12.7 cm])
- red or pink water-soluble marker
- white gesso
- watercolors
- #12 round watercolor brush
- pencil
- soft vine charcoal
- fine-grit sandpaper
- spray fixative

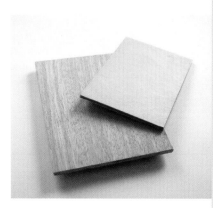

Wood: I have the hardware store cut down a sheet of ¼" (6 mm) birch plywood to my desired size or I purchase ready-made artist's wood panels from an art supply store.

❶ Using a red or pink water-soluble marker, draw in your design. If you make an errant line, don't worry; most of this step will be obscured by the end. Just reposition your pen and keep going.

❷ Paint a layer of very wet watercolor using several colors of your choice. Be careful not to obscure your red lines too much.

❸ Before your watercolor dries, add texturing with white gesso. Paint some areas smooth and some highly textured. The gesso will mix in with the pigmented watercolors. Again, paint up to and around your red marker lines. Let dry.

❹ Sometimes you will want to add another layer of gesso if the balance of textures and colors is still too jumbled and chaotic. This is a good time to loosely redraw any obscured marker lines as well.

❺ Decide whether you want to add more color to either the animal or background. Add a layer of transparent watercolor. Let dry.

❻ Repeat steps 4 and 5, if desired. Work each area of your painting until you are satisfied. Sometimes you may want to hit the piece with sandpaper to add subtle texture.

❼ With a pencil, outline your elements. I like to keep my hand very loose and sketchy during this portion. Add eye detailing, hair, and other line drawings to your painting.

❽ As a final step, add vine charcoal to your pieces to add shading, dimension, or texture.

❾ Spray with fixative.

tip ▶ The vine charcoal tends to darken a bit when you spray it with fixative. I compensate by laying down the charcoal to a point I like, then blowing on the piece softly before spraying with the fixative; this takes off just a bit of the charcoal so that when it darkens, it is just right.

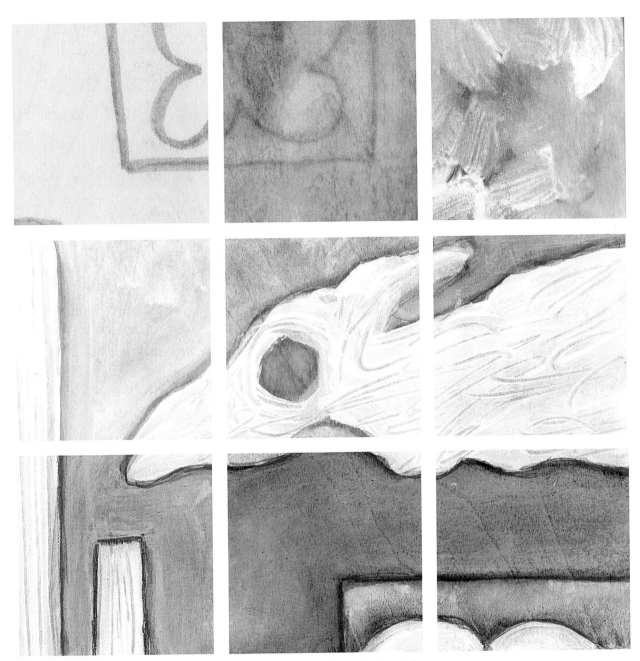

Here is a sample progression of steps 1 through 9. The red marker is mostly obscured by the last step, but traces of the red are still there, adding interest to the final painting.

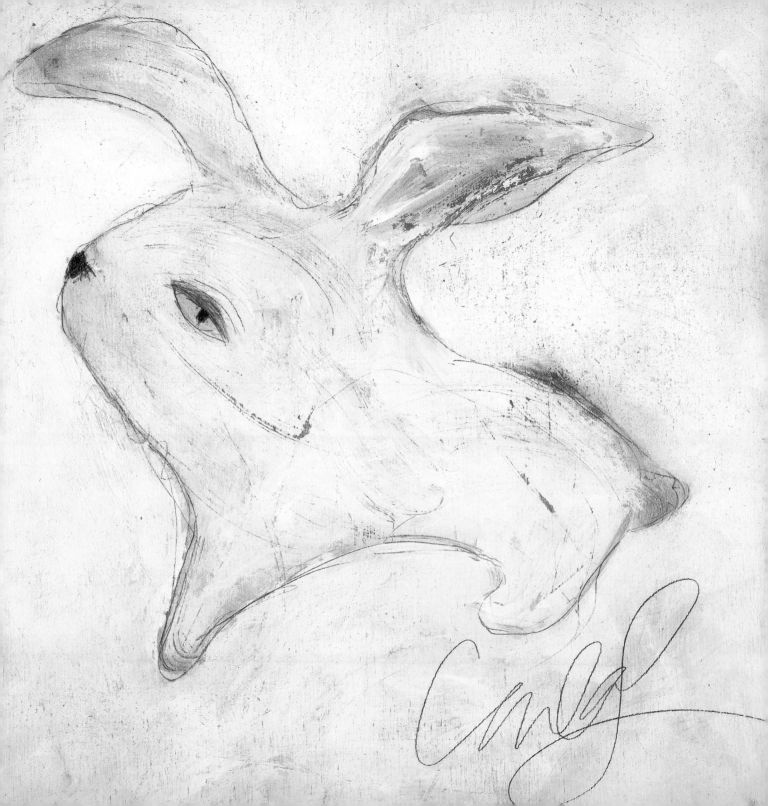

11

Creatures on Wood, Part II

Embracing Serendipity

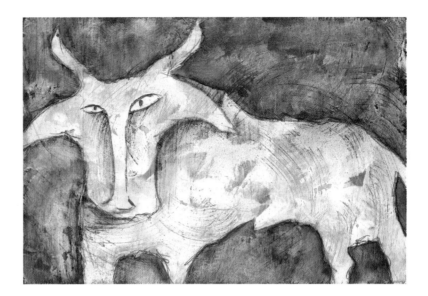

ACCORDING TO WIKIPEDIA, SERENDIPITY IS "WHEN SOMEONE FINDS SOMETHING THAT THEY WEREN'T EXPECTING TO FIND."
I might have misnamed this chapter, then, because in the case of these paintings, I *expect* to find a creature in the messy marks. I just don't know what kind it will be or what it will look like!

In this project, we are laying down more complicated marks than previously, which will in turn make it more difficult to find an animal. Don't worry, though. It might take a while, but in the end, a creature always appears.

I like to take Keith Haring's advice to heart: "The challenge is to be in a state of mind which allows spontaneity and chance while still maintaining a level of awareness which allows you to shape and control the image. Every drawing is a performance and a ritual."

Practicing serendipity is my favorite way to paint. The process is easy: smear some paint on the substrate and finish the creature that is started for you. Simple!

materials

- *wood substrate, size of your choice*
- *watercolors*
- *assortment of brushes*
- *white gesso*
- *pencil*
- *soft vine charcoal*
- *60-grit sandpaper (or similar)*
- *rag*
- *spray fixative*

109

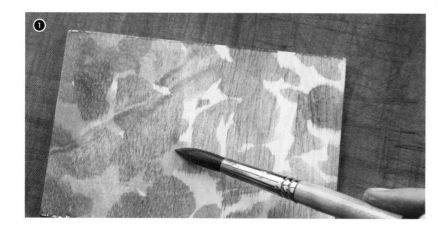

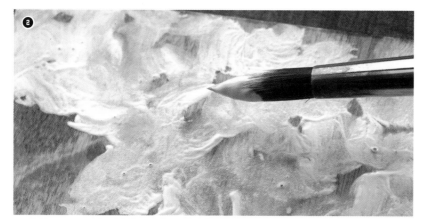

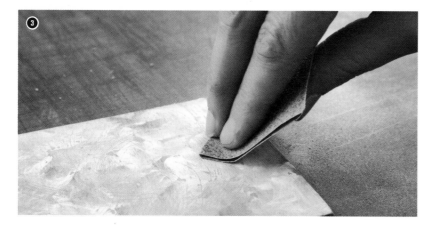

① Add a layer of watercolors all over the wood. Here I used the primary colors and let them overlap naturally to create secondary colors. Make sure the wood is covered completely.

② While the watercolor layer is still wet, add brushed dollops of white gesso. The watercolor pigment will mix a bit with the gesso, and you will get different shades of color. Move the brush in a sideways motion and kind of "scoop" the paint across the panel. If you find the gesso is not mixing with the watercolor underneath, dip your brush in water. Leave some "wood" showing through. Let dry completely.

③ Now take 60-grit sandpaper (or similar) and give it all a good scrub. You *want* to scratch lines in the gesso. Vary your pressure and your direction. I try to make sure the lines are curved slightly as well.

tip ▶ If you have an animal partially started but don't know how to finish it, look for some photo references in a pose similar to the one you've started to help you finish your creature.

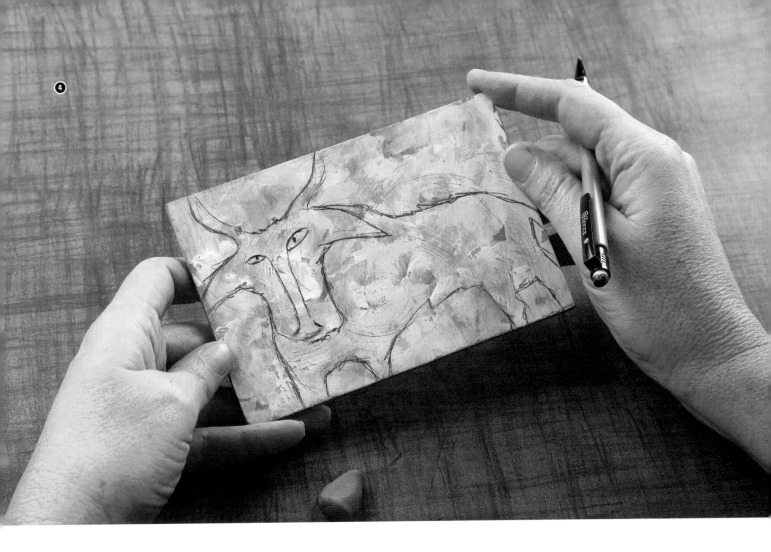

④ Once your painting is completely dry, turn it around and around. Texturally, your painting will probably be somewhat of a mess! But take your time and see if you can see the beginning of a creature. It's possible that you only see an ear, a paw, or something else—or nothing at all. If you don't see anything yet, get out your paint and repeat steps 1 through 3. If you do see something, outline your animal in pencil. Keep your hand loose, but don't be afraid to really draw into it, as you want these lines to show up in the final piece.

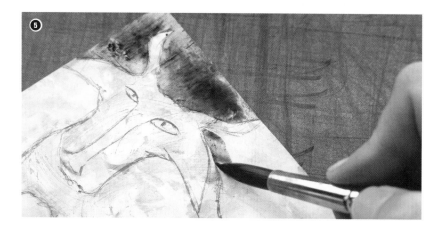

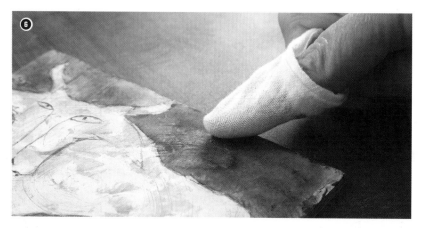

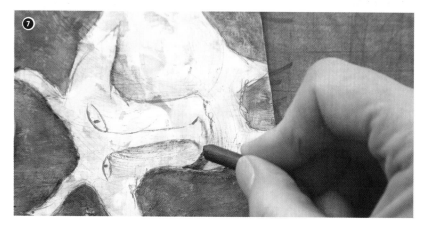

⑤ Now look at your painting and determine which elements (if any) you are happy with. For example, do you like the patterning and color of the creature as it is? Or the background? In this case I really liked the texturing on the animal, so I set my attention on the background, letting the animal (light, highly textured) dictate where I wanted to go with the background (dark, less textured). I usually aim to work one section of a piece until I'm satisfied, then I'll work the other, bouncing off the first.

To tone down the texture on the background, I laid down a watered-down layer of gesso. Once dry, I added a layer of dark blue watercolor.

⑥ Once your watercolor is completely dry, lift off some of the pigment with a slightly damp rag (see the technique on page 82).

⑦ Keep working the painting until you are satisfied. As a final step, add shading with vine charcoal. Spray with fixative.

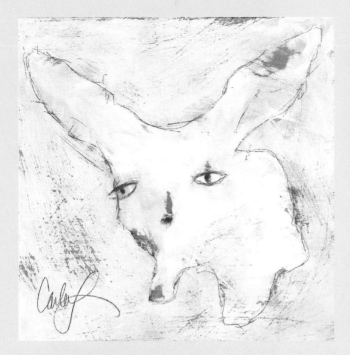

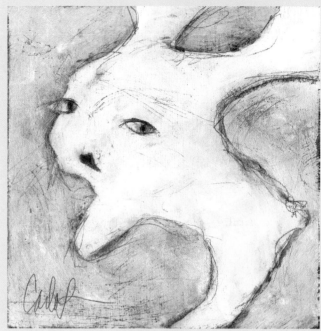

bunny power

The first painting I did that I ever really liked was of a rabbit. That was over fifteen years ago! I go in and out of subjects, though, and other things took my attention for some years. But in early 2011, I suddenly wanted to draw rabbits again. It was the Chinese Year of the Rabbit, and I happened to be a rabbit (b. 1963). My oldest son, Christer, was also a rabbit (b. 1987), and his baby son, Liam, was also a rabbit (b. 2011). Perhaps that is why rabbits started appearing in my sketchbooks more and more often; who knows?

Around that time, I also started a series of paintings and started out with the abstract approach in this chapter. But bunnies kept appearing in these "abstract-start" paintings. I was surprised that the rabbits I had been doing in my sketchbooks were coming up so consistently.

French scientist Louis Pasteur once wrote: "In the field of observation, chance favors only the prepared mind."

Because the rabbits were cropping up so often in my sketchbooks, I guess it was natural that they would appear in my paintings, too.

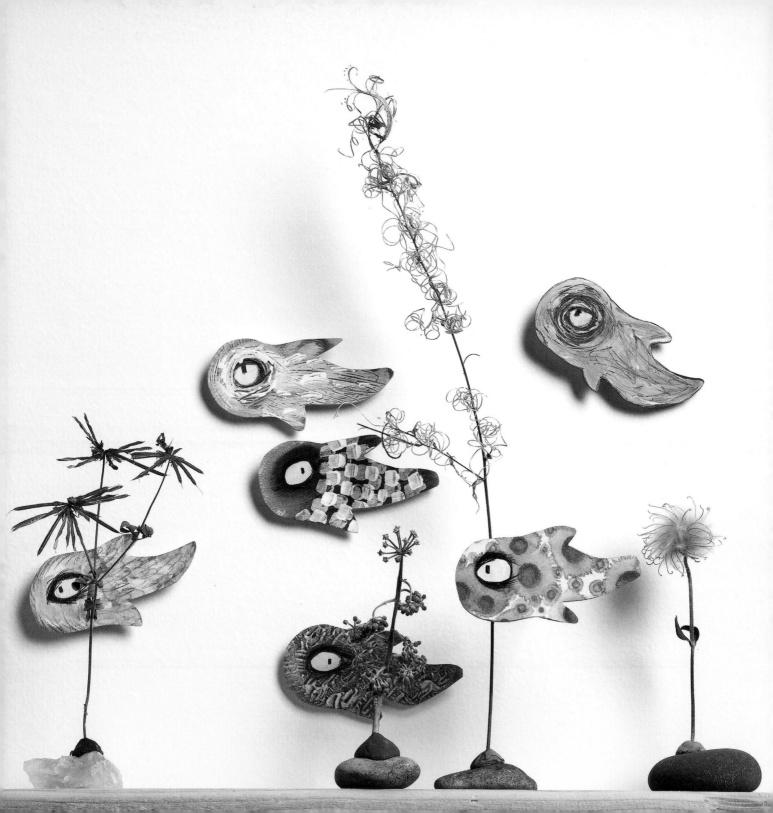

12

Go Fish!

Installation

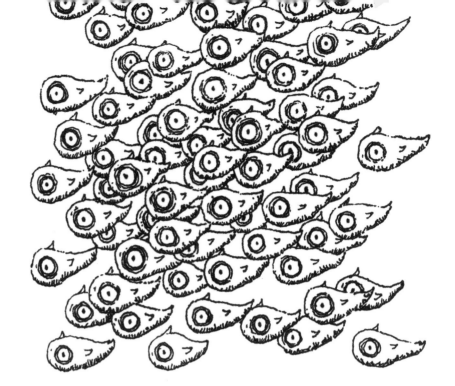

WORKING IN A SERIES IS A GREAT WAY TO BUILD A LARGE BODY OF WORK

In 2002, I painted 1,000 tiny faces and hung them all over the lobby of a local theater. Looking back, I see now that it was more installation than anything else; each little face taken separately was nice, but as a whole, an overwhelming whole, they made a show.

Since then, I've had the desire to do another installation project but hadn't been able to decide how to begin, as I didn't want to paint them on paper like I did the faces show. (They turned out to be too fragile unframed and, well, who wants to frame 1,000 3-inch [7.6 cm] paintings?)

And then I found my dream answer: paper-thin wood.

In this chapter, we'll take coloring and painting techniques from previous chapters and apply them to these individual mini creatures, which over time can become an impressive body of work!

Sketchbook pages like this one can provide inspiration for future paintings or shows.

materials

- sheet of 1/32" (0.8 mm) birch plywood, 6" x 12" (15.2 x 30.4 cm)
- gray Copic marker
- watercolors, gesso, markers, etc.
- scissors
- 120-grit sandpaper
- spray fixative

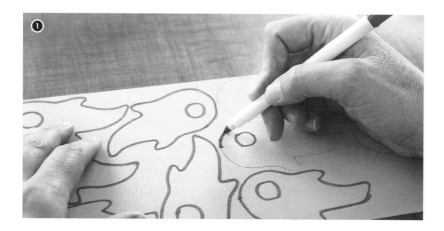

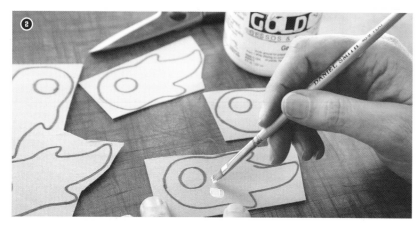

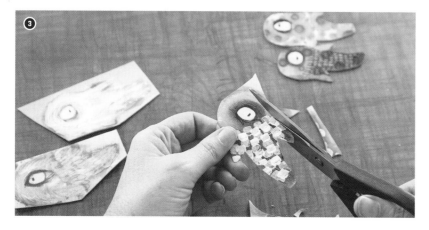

❶ Draw several simple fish shapes on a piece of paper. Pick the one you like the best and cut it out to use as a template. Trace around your shape with pencil, fitting as many as you can on your wood. Trace pencil lines with a pink water-soluble marker.

Note: It's best to pick a shape that is not too intricate if you are going to cut with scissors, as I do. If you would like to use other cutting methods (such as a craft knife or jeweler's saw), then you can make your shape more complicated.

❷ Paint as desired, using a mix and match of techniques found in the previous chapters. (See the next spread for some "recipes"). I like to cut them down loosely first and work each fish individually.

❸ Now cut out your fish, being careful in the nooks and crannies so as not to unintentionally lop off a fin. (You might start with a fish that you're not particularly fond of so that you are practicing on one that can be tossed if necessary!) Sand your edges with sandpaper.

❹ Depending on the color of your painted fish, you might want to edge the side of the fish with a gray permanent marker so that the light color of the natural wood is not so jarring. Spray with fixative.

Now you are ready to install your artwork. Use poster tape or even rolled-up masking tape to attach your fish directly to a wall.

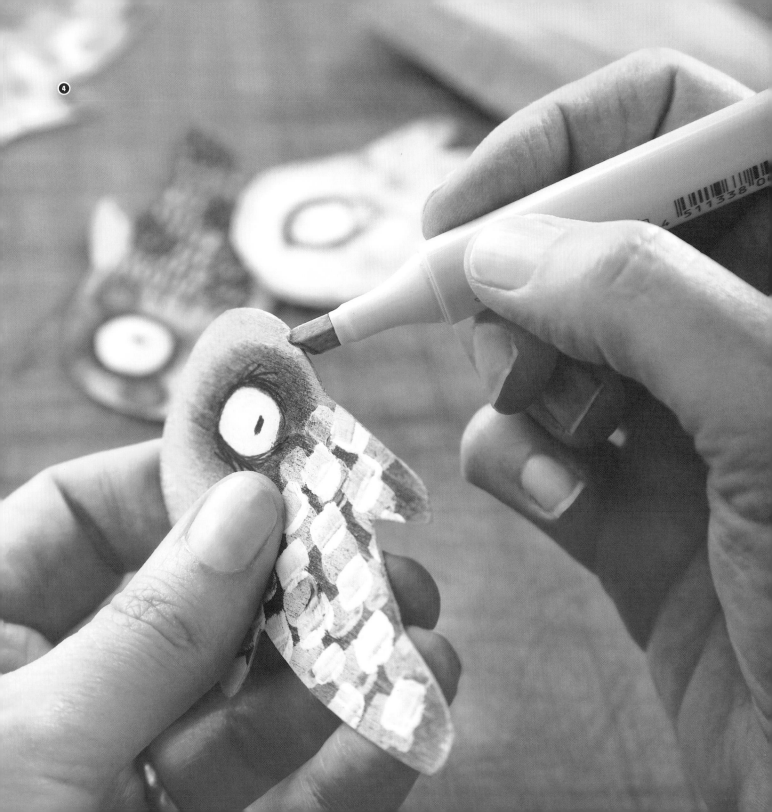

Painted Fish Recipes

The fish on this page were created using the painting techniques from the previous chapters. The media are listed in order of application.

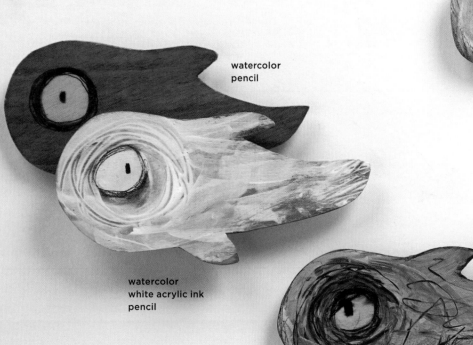

watercolor
pencil

watercolor
white acrylic ink
colored pencil
pencil

watercolor
white acrylic ink
pencil

watercolor
white acrylic ink
pencil

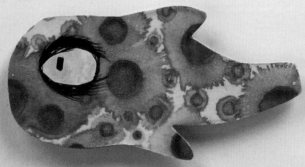

watercolor on transfer paper
ballpoint pen

gesso
watercolor
pencil

watercolor
white acrylic ink
pencil

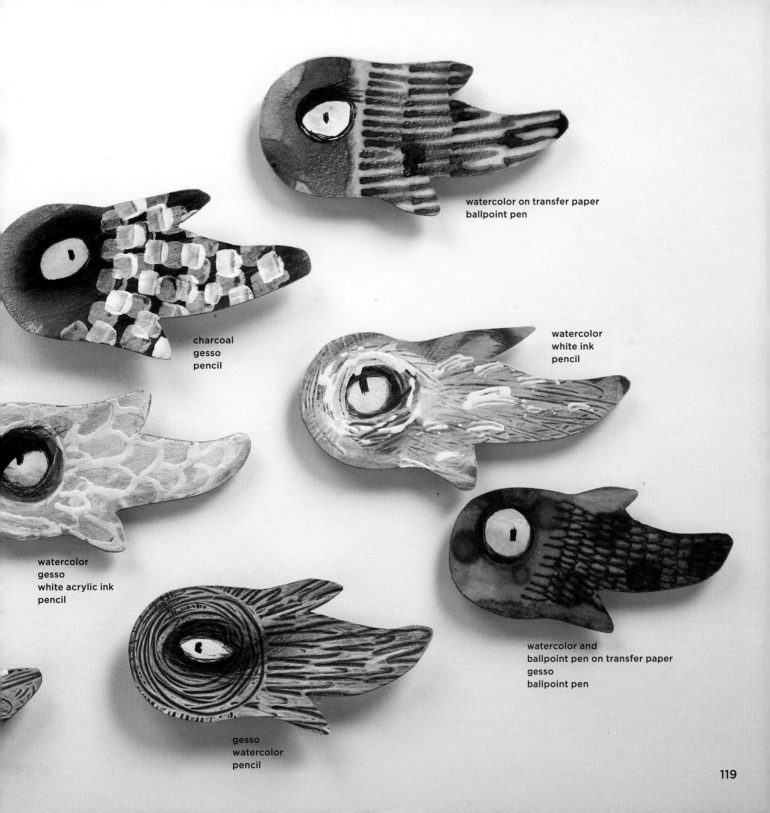

watercolor on transfer paper
ballpoint pen

charcoal
gesso
pencil

watercolor
white ink
pencil

watercolor
gesso
white acrylic ink
pencil

watercolor and
ballpoint pen on transfer paper
gesso
ballpoint pen

gesso
watercolor
pencil

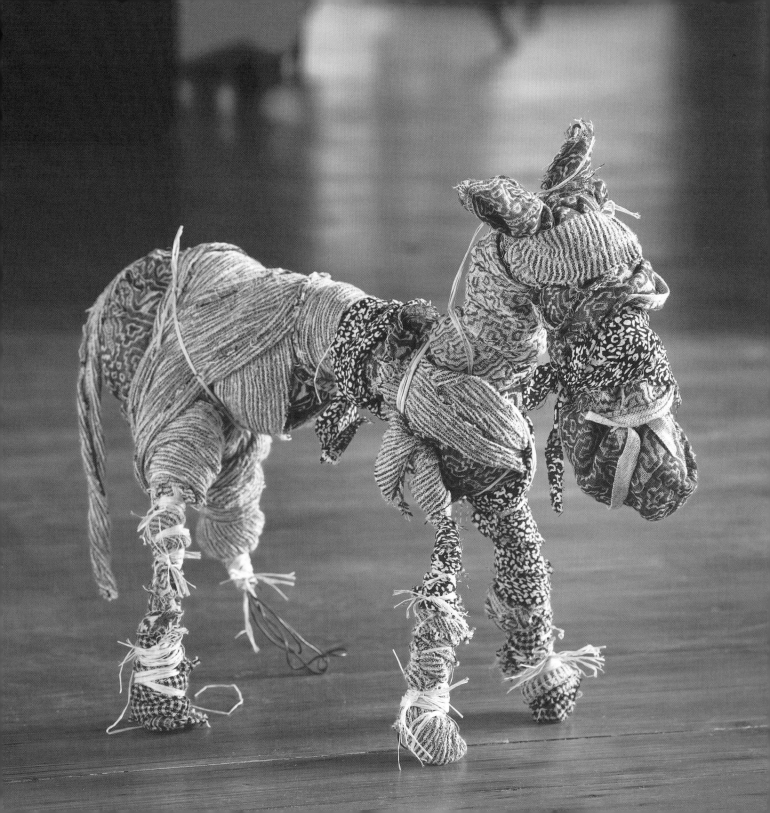

13

Wrapped and Tied

3-D Fabric Animals

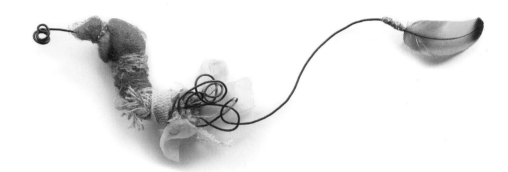

THIS BOOK WOULD BE INCOMPLETE IF I DIDN'T INCLUDE A SECTION ON THE FABRIC CREATURES I MAKE.

I love fabric and have a growing collection of mostly recycled fabric that I use to make purses, journals, and stuffed animals. More recently, I've been just wrapping and tying the fabric to create imaginary animals, partially inspired by Outsider Art and the wrapped creations (buildings!) of Christo and Jean Claude.

This project is quick to execute, will give you a break from drawing, and helps change things up in your creative world (always a good thing). Bonus: The creatures make excellent drawing and painting references!

A real feather was glued to the wire and then wrapped with yarn immediately (while the glue was still wet).

materials

- 1–4 feet (0.3–1.2 m) of baling wire (or other thicker wire that you can still bend with your hands)
- fabric scraps, cut to small strips or pieces about 3"–4" (7.6–10.2 cm) wide
- some string, twine, or ribbon
- wire clippers
- optional: buttons, needle, thread, glue, found objects

121

1. Clip a piece of baling wire about 2 to 6 feet (0.6 to 1.8 m) long, depending on the desired size of your final animal. Decide on an animal and just start making a frame. Twirl and twist the wire around. Think legs, heads, bodies, wings, and so on.

2. Gather lightweight fabrics. Cut pieces out as you go in small strips or patches, about 3 x 6 inches (7.6 x 15.2 cm). Wrap and tie with string or twine. Continue until you have a creature you like!

3. Sometimes you might need a needle and thread to secure some errant fabric or buttons for eyes. But mostly everything can just be held together with string, twine, or ribbon.

▲ Baling wire gives your creature a sturdy framework and can be found in most hardware stores.

▼ When collecting fabric, I look for pieces that are lightweight and look nice on both sides. I tend to gravitate toward blacks, grays, and browns but will add a bright color every once in a while to spice things up and force myself out of my comfort zone.

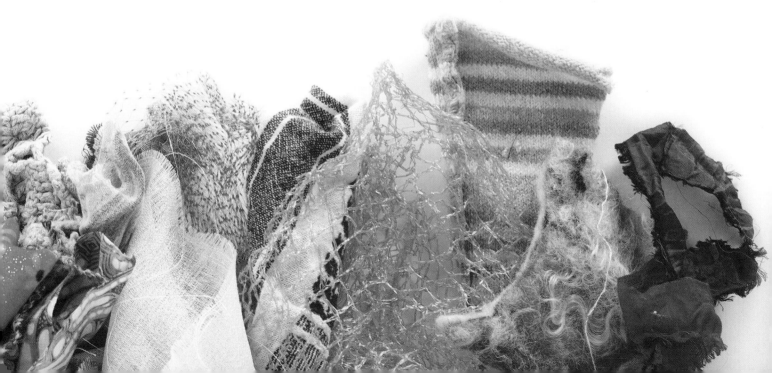

This abstracted pet frog is by
fourth-grade student Colten Yager.
Pencil and watercolor on paper.

Colten Yager

Artist's GALLERY of Inspiration

I'm guilty of spending way too much time on the computer looking at other people's art rather than doing my own work. But there is so much beautiful stuff! The line work, the color choices, the compositions are all so good. And I couldn't replicate these artworks even if I tried!

Of course, that's the beauty of life and art; we are who we are, and there isn't really a single thing we can do about it.

It's okay, though, to be inspired by the work of artists you admire. Like everything, your subconscious will pick up sensibilities that eventually will make it into your own work, but with your own unique flavor and spin.

The art pieces represented on the following pages are made by friends, Internet acquaintances, or complete strangers, but there's one thing they all have in common: I wish their piece was mine!

FEATURED ARTIST
**Petra Overbeek Bloem
Samuels Brusse, the Netherlands**

My Dog, Chinese ink on rice paper.
"This technique requires that it is done in a single brushstroke; you cannot correct or adjust. (That is what I love about the technique. It makes the adrenaline flow and makes me concentrate fully on the now.) Chinese ink is water based, which means you can achieve all sorts of shades of gray, which I used here. The dog is my own dog, Ventje, Dutch for 'little guy.' I painted it from a photograph."

Matteo Cocci
Prato, Italy

Rabbit, mixed media on wood.
"What I create always rises quite by chance. I usually work with everything around me, things on the table, whatever is available, such as little pieces of paper already used in former artwork or ripped out from books. I use oil pastels, acrylics, and pointed objects to draw the shapes. At the beginning, I don't have a clear idea about what I'm going to do, but from the chaos, I start to see the shapes: one ear, eyes, a paw, a tail. I follow the idea the work itself suggests to me . . . and if it is interesting, and I have been good in interpreting it, I go on and something appears on the surface of the painting, figures, images like this, animals coming from I don't know where, exactly. But actually they were already there, hidden somewhere in my mind and in other pieces, places, and thoughts . . . and, slowly, they appear, drawing the paper, and I just follow them; I trust them and they trust me. Then they become visible to everybody. I paint them because I would like to be like them.

"But I wear shoes to walk . . ."

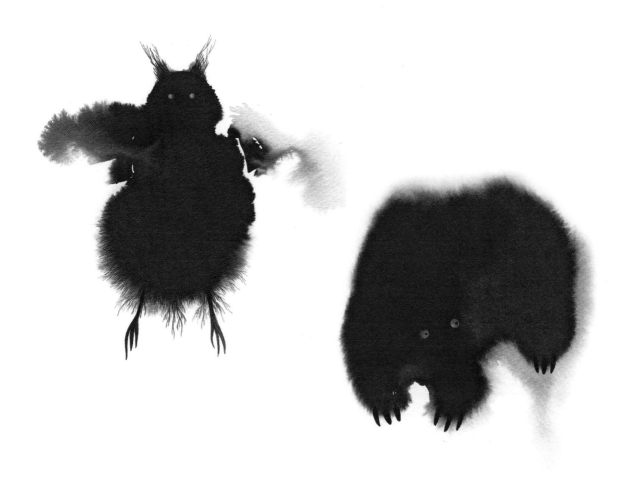

Julie Lapointe
Montreal, Quebec, Canada

Owl and Bear, ink on paper.

"I imagine this is what I must have looked like when I first got back to drawing; intimidated to near paralysis, like a deer in the headlights. Where to start after all those years? And then it came back to me: the inkblot technique done by wetting the paper, dropping large or small amounts of ink, and working with the patterns that naturally form.

 "More often than not, a beast or some chimera stares back at me: bird, bear, fish If not, I just play around with the shape, add texture, and try to give it depth by adding or sub-tracting ink.

 "I can now control a little of what happens by using more or less water on the paper or by directing the brush a certain way when dropping the ink, but my subconscious still does most of the work!"

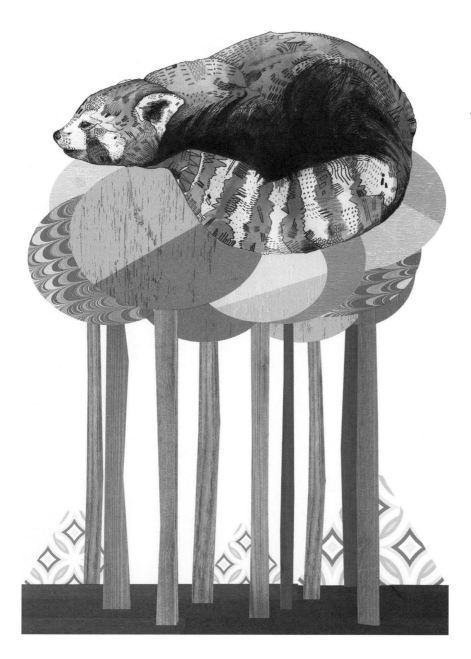

**Sandra Dieckmann,
London, England**

Red Panda, pencil, pen, ink, watercolor, and digital collage.

"My head is full of stories and creatures and conversations. I can't be any other way. Sometimes I think it is the way I was allowed to be free without fear so early on that ignited this dreaminess. I explored the woods, spent loads of time reading, drawing, and just making things. I think I just never stopped.

"This little fellow just emerged in front of my inner eye and was brought to the paper very naturally without too much planning. He is one of my favorite animals and a dream to draw. I like working unrestrained, and I like to think of myself as a storyteller. Just someone that has countless images and ideas floating in and out of my head and that can't help but let them out."

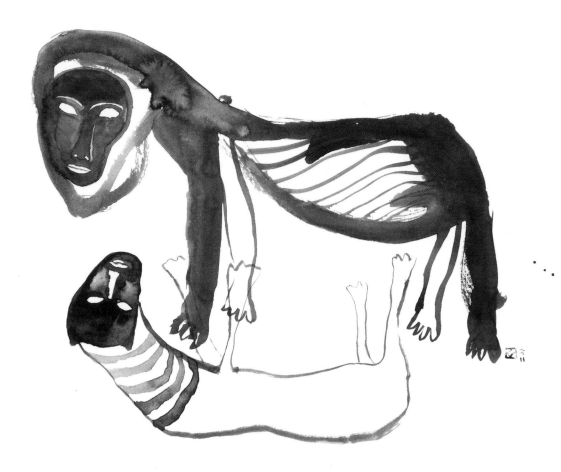

FEATURED ARTIST
Valeria Kondor
Hyderabad, Andhra Pradesh, India

Lions, watercolor on paper.
"This single-stroke painting of the two animals, I called *Lions,* for lack of a better idea. But in any way they are powerful and strong as their lines are. They are about sameness, connection, bonding, and dominance. One has a male, another has a female appearance, so they may be a couple. They float or rest in the undisturbed space; it's only about them now.

"Another way it can be the Lion and its reflection, mirror image, shadow, or imagination. The saturated, earth- and water-colored watercolor marks firmly run to define the figures. The viewer can approach them from their human but styled mask face. We humans think all which has soul has got human face. We tend to measure everything by our own measures. And it may be even good if we really see ourselves in everything and everyone."

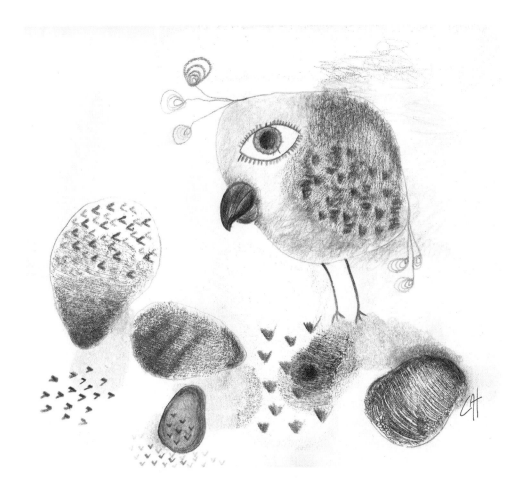

FEATURED ARTIST
Catriel Martinez
Buenos Aires, Argentina

Pájaro Solo, colored pencil and gesso on paper.
"I created this drawing spontaneously. First I started to play with colored pencils, making some shapes, and after that, one shape suggested the body of the bird, so I did it.

"I have two different and opposite ways to approach work: in some of my drawings, I work in a very spontaneous manner, while in others, I think a lot about what I'm going to do, premeditating things. Anyway, both approaches connect in some part of the creative process and end up intertwined with each other. Sometimes I can think and plan carefully in advance, but it's in the act of drawing that new forms appear, making the narrative richer and taking it to a new, different direction."

FEATURED ARTIST
Ava Wood
Eden Hills, Australia

Monster Fin Fin by Ava, 5 years old, pen and watercolor.
"I like pictures that are colorful, like rainbows. There are also
lots of different patterns you can use for decoration. A fin fin is
called a fin fin because he has lots of fins. He lives in the ocean
in the shallow water. Children at the beach see him and hug
him and he gives them piggyback rides. Grown-ups just like to
take photos, but they don't normally see him. A fin fin is as big
as a shark, but he's very friendly and doesn't have sharp teeth."

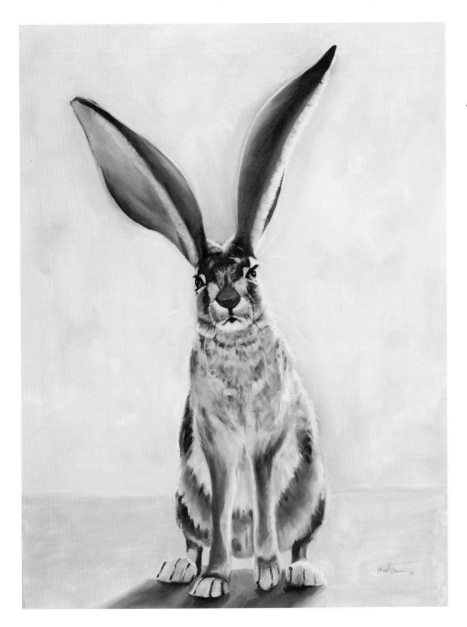

Karine Swenson
Joshua Tree, California, USA

Badass Jack, oil on canvas.
"I have always loved to paint and draw people. What interests me is the individual. When we moved to the desert about five years ago, the wild desert animals caught my attention. I think of these paintings as character studies.

"This jackrabbit painting was inspired by the black-tailed jackrabbits that I see in the desert every day. Their ears are enormous, and their ability to survive in the desert amazes me. I have seen them eat cactus covered in spines when they are hungry enough. I wanted to create a character—an exaggeration of these wild creatures. This painting is the result."

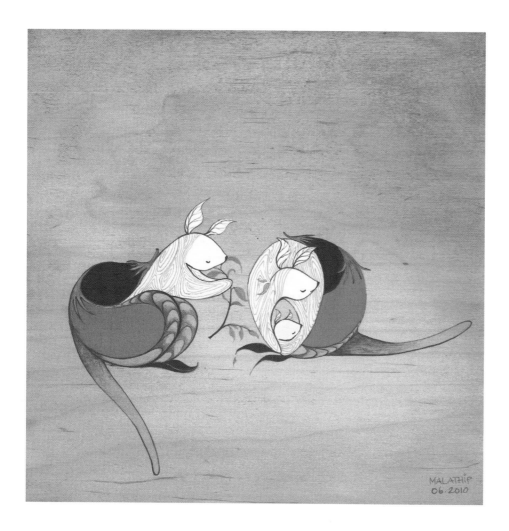

FEATURED ARTIST
Malathip Kriheli
New York, NY, USA

Love Being Different, acrylic on wood panel.
"My work explores natural subjects with an emphasis on raising
awareness for endangered animals. Although my pieces begin
with planning and forethought, they really come to life as paint,
colors, lines, and values interact."

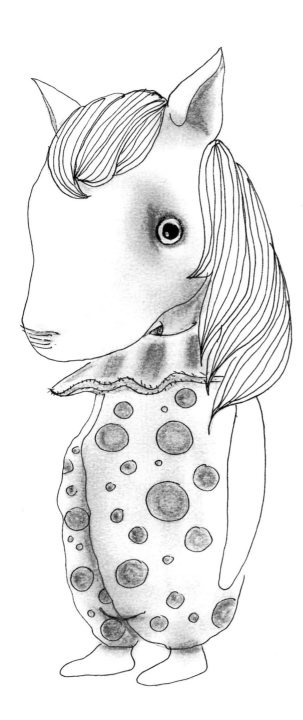

FEATURED ARTIST
Karen O'Brien
Grants Pass, Oregon, USA

Circus Pony, pencil, permanent ink marker, and Contè pencil. "I use a lot of color in my art, so I decided to give myself a challenge and do some drawings using a minimal number of tools. I love drawing three-dimensional objects; it gives my drawing 'eye' the challenge of existing light, shadow, and texture. My favorite 3-D objects are handmade animals and dolls. I spent many childhood hours drawing my favorite Raggedy Ann and Andy. I am captivated by contemporary soft-sculpture art. The creativity with form just begs for a drawing. This is a drawing that was inspired by a pony created by a talented soft-sculpture animal artist, Whendi Meagher."

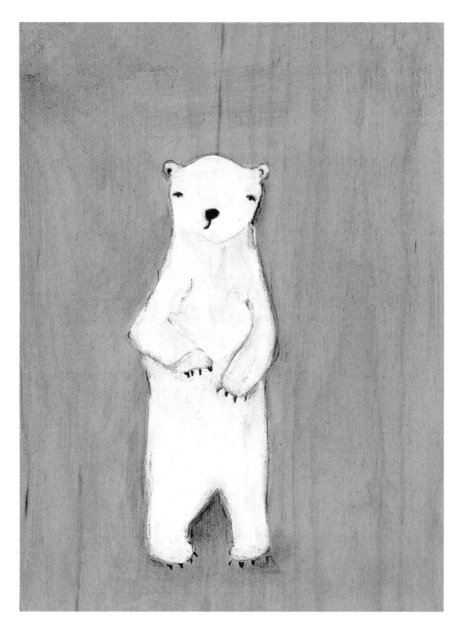

FEATURED ARTIST
Marisa Anne
Los Angeles, CA, USA

Do you know what I mean?
acrylic on wood panel.

"My practice of daily painting that began in 2006 is exactly what led me to paint in my present style. I've always had a love for animals, and as a child, my favorite collections were of stuffed animals and tiny animal figurines. Also, growing up as an only child, the animals in my life, ranging from a dog and cat to a guinea pig and a cockatiel, often felt like kindred spirits, especially on the days when I might have felt more alone. I would often choose to paint and draw them as well, so it is really no wonder that they found their way back into my creative expression today. They appeared in my work right when I needed them most. Looking back now, I can see clearly that they offered me the same gentle, reassuring, and kind support while I was building my business, Creative Thursday. There were many days when I did not know how it was all going to come together. I just knew in my heart that I had to keep painting. It is almost as if the characters came out just at the right moment to cheer me on and calmly remind me that everything was going to work out fine."

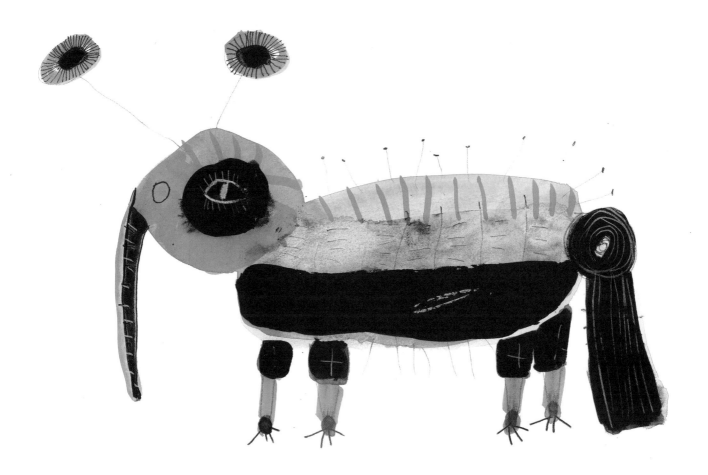

FEATURED ARTIST
Marina Rachner
Weinheim, Germany

Red Animal, acrylic and pencil.
"This picture developed from the oval body in the middle. I used strongly diluted acrylic paint because I wanted the color to spread more easily, similar to watercolor. In this way, I could almost let the brush find the form itself. Thus the trunk also formed more or less randomly.

"After the color thoroughly dried, I used black as a contrast. The fine pencil lines are intended to set an antipole to the more or less rough use of color; it should also make the animal appear to be more fragile."

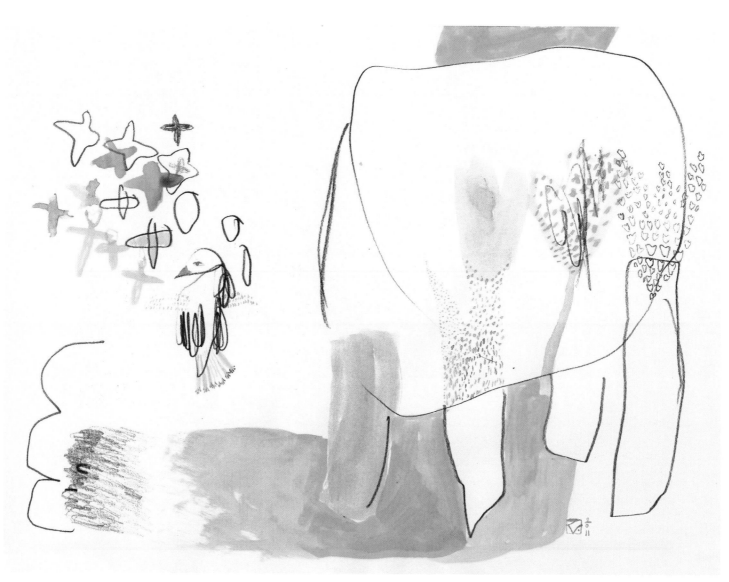

Tulip Pigeon, watercolor and graphite by Valeria Kondor

about the contributors

MARISA ANNE is an artist living in Los Angeles. She began Creative Thursday with an intent to be more creative one day a week. Now Creative Thursday has become home to a family of friends, many of whom wear hats, hold hands, and encourage you to follow your dreams too.
www.creativethursday.com
Email: marisa@creativethursday.com

PETRA OVERBEEK BLOEM was introduced to sumi-e in the 1980s. She writes, "I was fascinated; the power of a single brushstroke is overwhelming. To paint with ink and Chinese brush on rice paper gives me energy, strength, and joy. I started to paint in the old Eastern tradition, but being a Western woman in this day and age, I had to find my own way. The technique stayed the same, but growing up and living in the Netherlands has made its mark."
See more of Petra's work at www.pobsb.nl
Email: POBSB-art@ POBSB.nl

MATTEO COCCI is an artist from Prato, Italy. See more of his work at www.mmateococci.it and www.flickr.com/photos/matteococci/
Email: matteococci@gmail.com

SANDRA DIECKMANN is a London-based illustrator. "I think I've never stopped creating since I was that little girl," says Sandra. "There's a wild child in me and a very mature, analytical adult. I can laugh at clouds and cry about beautiful trees, but I'm also deeply interested in the psychology of humans. If there's one thing I've learned after caring for my mom who died in 1998, it's that you can't work against your basic design. Life is short. Always be honest to yourself. For me, that means doing what I do."
Find Sandra online at www.sandradieckmann.com.
Email: sandradieckmann@googlemail.com

LISA FIRKE says a perfect day is when she gets to read something, write something, and make something. She shares her ideas and works in progress at www.lisafirke.com.
Email: lisa@lisafirke.com

DAR HOSTA is an author, illustrator, and educator living in central New Jersey. See her illustrations and find her award-winning children's books at www.darhosta.com. Her *Cranky Birds* can be found at www.crankybirds.wordpress.com, and her email is darhosta@mac.com.

VALERIA KONDOR is an artist from Hyderabad, Andhra Pradesh, India. She writes, "Creating images is joy, challenge, therapy, and fun for me. They generate enormous energy. My driving force, when painting, is to discover and feel the nature and character of a mark and answer with another mark. This way the communication among colors, shapes, and textures is going on until the image gets into shape. My images are built with kind of layers, so these days, besides painting, I make collages." See more of Valeria's work at www.flickr.com/photos/13901617@N06/.
Email: vkondor@hotmail.com

MALATHIP KRIHELI is a New York City-based visual artist that specializes in graphic illustration and painting (both watercolor and acrylics). Born and raised in Thailand, she earned her degree in interior architecture before settling in the United States. She lives on New York's Upper West Side with her husband and son.
www.malathip.com
Email: malathipkriheli@gmail.com

JULIE LAPOINTE currently lives in a little house in the Eastern Townships (Quebec) with her boyfriend and cat, next to a frog-friendly lake surrounded by hundreds of acres of forest. The place is really peaceful and ideal for her journey back into a not-so-virtual creation! She writes, "As far as I can remember, I have always felt the need to create things. One of my first memories is making tiny boats out of nut shells! When came the time to study, it seemed natural to go with fine arts. My interest for multimedia came later on. After completing a degree, I started to work as a website designer, and since then, I have slowly drifted away from my real passion: drawing and creating objects. Recently I've started again."
Find Julie online at www.datcha.ca/la_datcha/
Email: ladatcha@datcha.ca

CATRIEL MARTINEZ is an artist from Buenos Aires, Argentina. He writes, "I really enjoy working with my hands. I didn't choose it; it's something that comes naturally. I like to experiment with different tools and techniques and discover where they can take me. So far, my favorites are inks, gouache, colored pencils, and collage. Each of them, in their own way, allows me to tell a story and discover new things."
www.catnez.com.ar
Email: info@catnez.com.ar

KAREN O'BRIEN lives and works in Oregon with her husband and two miniature dachshunds. She writes, "I am a child at heart. I love dolls, teddy bears, and animals of every shape. I am inspired by textiles, patterns, color, and all things vintage. I have been making teddy bears and cloth dolls for more than twenty years, and they always start with a drawing. My drawings, journals, and paintings are filled with imaginary characters—animals and people with oddly distorted features and eyes that express a soulful, quirky personality. Find Karen online at www.karenobrien.com and www.karenobrien.blogspot.com
Email: quietbear2@gmail.com

German artist **MARINA RACHNER** writes, "Drawing and painting for me is a way to express myself and the ideas that are swirling around in my head. To play with color, let color speak, and to let something develop out of this helps me to experience a great deal of freedom that I need beside my work as a children's book illustrator.
www.flickr.com/photos/marinarachner
Email: mrachner@gmx.de

KARINE SWENSON is a visual artist living in the high desert of Southern California, near Joshua Tree National Park. She paints in oil, watercolor, and pastel. Her abstract or nonrepresentational paintings are a visual exploration of color and form. She also has a life-long interest in painting and drawing the human figure.
www.karineswenson.com
Email: karine@karineswenson.com

AVA WOOD is five years old and likes to art journal with her mother, Lynda Wood. Contact Ava (through Lynda) at moonflitter@gmail.com.

COLTEN YAGER was in fourth grade when he completed his artwork when in art class with the author.
Email: coltenyager@yahoo.com

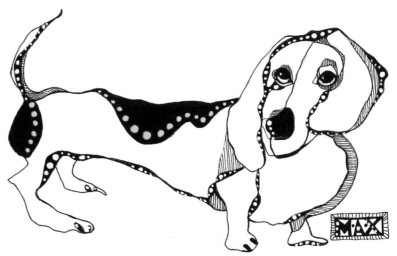

Max by Karen O'Brien, pencil, permanent ink marker, Conté pencil, white gel pen, and blue Sharpie paint pen.

thanks!

I want to thank the following people for helping to bring this book together.

My husband, Steve, for the many pep talks. (Thanks, honey.)

My two sons, Wes and Christer, and Christi and baby Liam; thanks for the inspiration!

My editor, Mary Ann Hall, and art director, Regina Grenier: thank you for your patience and cheerfulness! Thanks also to Publisher Winnie Prentiss, Betsy Gammons and all the other good folks at Quarry Books.

My supportive family and friends

All the wonderful contributors

My students over the years

about the author

CARLA SONHEIM is a painter, illustrator, and creativity workshop instructor known for her fun, innovative projects and techniques designed to help adult students recover a more spontaneous, playful approach to creating. She is the author of *Drawing Lab for Mixed-Media Artists* (Quarry Books) and *The Art of Silliness* (Perigee). She lives in Seattle and shares space with her photographer husband, a game-playing teenager, and her blog.

www.carlasonheim.com
www.carlasonheim.wordpress.com
Email: carla@carlasonheim.com

Also Available from Quarry Books

Water Paper Paint
ISBN: 978-1-59253-655-9

Art Lab for Kids
ISBN: 978-1-59253-765-5

Drawing Lab for Mixed-Media Artists
ISBN: 978-1-59253-613-9

The Art of Urban Sketching
ISBN: 978-1-59253-725-9

One Drawing a Day
ISBN: 978-1-59253-724-2

Mixed-Media Girls with Suzi Blu
ISBN: 978-1-59253-769-3